CAPTURING POSEIDON

Photographic Encounters with the Sea

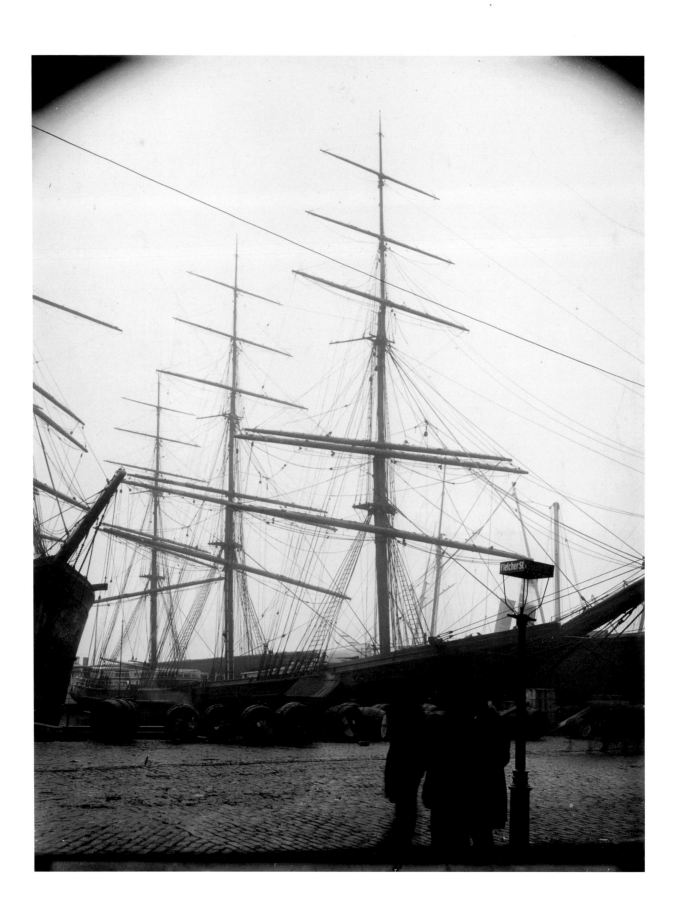

CAPTURING POSEIDON

Photographic Encounters with the Sea

Daniel Finamore, *Curator*

Russell W. Knight Department of Maritime Art and History

PEABODY ESSEX MUSEUM
· Salem, Massachusetts ·

The front cover albumen print is a detail of
In the Ice, 1879, attributed to Jerome J. Collins (image 28).

The frontispiece gelatin-silver print is of the
Ship A. J. Fuller *at South Street, New York, circa 1895*
by Thomas Addis Emmet Luke.

The back cover daguerreotype is that of the
Ship Reindeer *in the Phillipines, September 1850* (image 1).

Peabody Essex Museum Collections for 1998

Volume 134

ISSN 1074-0457

ISBN 0-88389-112-3

The *Peabody Essex Museum Collections* is an annual monographic series published in Salem, Massachusetts. All correspondence concerning this publication should be addressed to the Editor, *Peabody Essex Museum Collections,* East India Square, Salem, Massachusetts 01970. Previous volumes are available upon request. This book was copyrighted in 1998 by the Peabody Essex Museum.

Unless otherwise noted, all photographs are from the collections of the Peabody Essex Museum.

CONTENTS

FOREWORD

By Dan L. Monroe

This volume is intended to appeal both to those with an interest in the history of photography and also to the general maritime enthusiast. From the very earliest years of experimentation in the medium, photographers have found inspiration for their subject matter from the maritime environment. Such inspiration has been the source of a very special type of photography, one that strives to capture those moments, whether sublime, thrilling, or threatening that define humanity's innate attraction to the sea. Photography of the sea runs the gamut from the carefully composed and printed works of trained professionals to the spur-of-the-moment snapshots captured by amateur photographers from a beach or a ship's deck. Some of these images are marvelous for their perfection while others exude excitement through bold contrast, evocative light and shadow, or a disturbing juxtaposition of ship and shore.

Selected images from the Peabody Essex Museum photography collections have been well disseminated in academic journals and textbooks and in more popular books and magazines for many years. Most of those photographs present classics of maritime history with instant name recognition that are always in demand by viewers: famous clipper ships, ocean liners, and yachts along with portraits of the captains and designers. The photographs in this volume present no particularly famous individuals, and only a few famous vessels. The intent of this volume is not to depict historic ships or the famous mariners who sailed in them. Where they appear, it is only because the picture warranted selection on a purely aesthetic basis. The majority of these photographs, then, have not been widely seen by the public, and many of them have never been published or exhibited before.

Although the organization of images within the catalogue is a generally chronological one, it is not arranged in any fashion intended to emphasize developments of photographic or maritime technology. Similarly, grouping the photographs into sections based on the activities and industries they portray would have been equally inappropriate. The gallery of images opens with an American ship in a far-off port and closes with a memorial to a sailor. The reader is invited to make any number of connections among the photographs in between.

ACKNOWLEDGMENTS

Unlike projects that focus on discretely defined and narrow subjects, this selection of images covers a great span of time and a broad geographic range as well as a diversity of maritime subjects and photographic techniques. As a result, there is an equally broad array of people who contributed their specialized knowledge, labor, and enthusiasm. Not every photograph required or even warranted extensive documentary research, but for those that did, the accuracy and detail of the accompanying information is due in great measure to their contributions.

Of the many professionals from other institutions, Chris Steele, curator of photography at the Massachusetts Historical Society, was particularly generous with his time and limitless enthusiasm for photographic history. Others include Peter Bittner and Shane Young, Spring Street Digital; Mary Jean Blasdale, New Bedford Whaling Museum; Andrew Boisvert, Rhode Island Historical Society; William Cox, Smithsonian Institution Archives; Holly Hinman, New-York Historical Society; Paul Hundley, Australian National Maritime Museum; Junichi Kobayashi, Edo-Tokyo Museum; Paul Messier, Boston Art Conservation; Ellen R. Nelson, Cape Ann Historical Association; Mary Frances O'Brien and Laura Patterson, Boston Public Library; Bill Peterson, Mystic Seaport Museum; Stephanie Ovide, Donna Karan Inspirational Library; Diane Shepherd and Ken Turino, Lynn Historical Society; Michelle Tolini, Sotheby's Fashion Department; and Robert Young and Mary Sears, Museum of Comparative Zoology, Harvard University. Others who contributed to the success of the project include Patricia Bellis Bixel, Anna Bowditch, Susan Bowditch, William Bunting, Leonard Guttridge, Selina Little, Benjamin Mendlowitz, and Tony Peluso.

Numerous volunteers in the museum's maritime art and history department put in countless hours chasing down obscure facts and historical minutiae from various archives. We are especially indebted to Josephine Carothers, Charles Cobb, Mitchell Comins, Richard Gordon, Bob Ramsdell, and Tom Sleeper. Staff of the Peabody Essex Museum who assisted within their respective specialties include Mark Sexton, Jeff Dykes, and Jean Rees, all of the photography department, as well as William Sargent, Will La Moy, Jane Ward, Kathy Flynn, Dean Lahikainen, and Keiko Thayer.

Olivia Parker skillfully assembled the photomosaic that appears in image 51. A final acknowledgment goes to the Marine Society at Salem in New England for their generous financial support of the exhibition, and for their unflagging interest in maritime art and history activities at the Peabody Essex Museum.

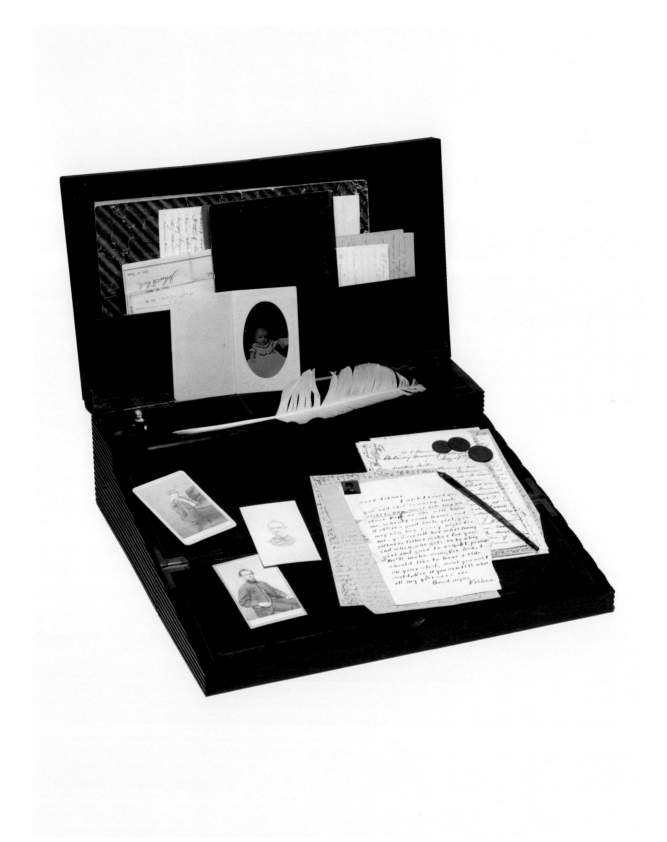

Figure 1. Writing desk and its contents belonging to Capt. Benjamin Briggs of the ill-fated Mary Celeste.

CAPTURING POSEIDON

WITHIN THE MARITIME COLLECTIONS OF THE PEABODY ESSEX MUSEUM IS A brown wooden portable desk that, when closed, appears to be nothing more than a ribbed box with a lock. When unfolded, a green felt writing surface is exposed, surrounded by small depressions designed to hold writing implements, ink, and blotting paper. A slot in the top is stuffed with business letters, receipts, and some small personal items, including several nondescript photographic portraits that are glued to heavy card stock. The pictures are of a typical New England family of the 1860s. The desk and its contents, once possessions of Captain Benjamin Briggs of Massachusetts, were removed from the ill-fated brig *Mary Celeste* after she was discovered under sail in mid-ocean, but with not a soul on board her. Intense scrutiny by investigators failed to uncover the fate of the captain, his family, or the crew. After the inquiry, the desk and a few other small personal items were given to the one family member who was not on board at the time, the captain's young son who was left at home in Marion to attend school.

For Captain Briggs while voyaging at sea, these wallet-sized photographs were simple reminders of a family that was temporarily separated by the necessities of a maritime existence. For the orphaned boy and all who view them today, they are the stark, ghostly reflections of individuals who remain inextricably linked to one of the greatest ongoing maritime mysteries of all time.[1] Although neither a ship nor the sea appears in any of these pictures, they are quintessential examples of maritime photography. Photographs that were inexpensively produced and reproduced were ideally suited to the needs of mariners and their families. The cheap, small photographic cabinet cards and still smaller carte-de-visite portraits of loved ones at home were commonly part of the personal belongings kept within the extremely limited space allotted to mariners while on their long and lonely voyages. These portraits of wives, parents, and children traveled the world with them, while pictures of those who were at sea remained at home as treasured memories of missing loved ones.

Portraits such as those of the Briggs family present one facet of the varied imagery that forms the multidimensional genre of maritime photography. Taken out of their context, the pictures would be simply another set of unremarkable family photographs, a few of the thousands produced in the nineteenth century. Found aboard a deserted ship, however, these images are the sole visual reminders of a family who devoted their lives to the sea. It is this ambiguity that renders maritime photographs all the more fascinating to look at and to ponder. Maritime pictures of many types, such as those portraying Western mercantile activity in Asian treaty ports, are heavily laden with meaning and intention, and are both conscious and unconscious constructions on the part of the photographer. The various subjects that make up maritime photography—ships at sea, portraits of mariners, colonial encounters, seascapes, studies of shipboard life, and exotic ports-of-call, to name just a few—all possess multiple interpretive orientations for both the photographer and the viewer.

Although most commonly analyzed solely for the visual message that was created by a photographer to be observed by a viewer, photographs are actually three-dimensional objects, artifacts that have histories of their own. Sometimes a battered old photograph betrays its history of having been carried in a wallet or exhibited in a sunny room for too long. Most of these histories are not reconstructible, but the evidence of their treatment is intriguing nonetheless. Such is the case with a photograph (image 89) that tells a gripping visual story of the crew of a schooner in distress. The sailors, probably fishermen, were in the midst of an extremely perilous situation when the photograph was taken, and the postures of those aboard and the wave approaching them show that their predicament might get more difficult yet. Perhaps the battered condition of the photograph itself is evidence that it served a long life as a remembrance for a survivor of the experience.

In some cases, the known history of a photograph as an artifact matches or even exceeds its visual content in interest. A set of five albumen photographs with curious pencil notations on the backs entered the museum collections many years ago. The photographs were obviously taken in the high Arctic, depicting fields of icebergs, some surrounding sailing vessels. On the back, the words "Salvaged by Raymond Newcomb, Naturalist and Taxidermist on the Jeannette Expedition" suggest that these photographs were taken during an ill-fated scientific voyage to the Arctic. The steamer *Jeannette* departed from San Francisco for the Bering Strait in 1879, intending to travel farther north than any previous expedition. By September, they were frozen into the ice above Siberia, where they stayed until the ship was crushed and sank. First by sled, then lifeboat, and finally on foot, the crew carried themselves and their meager supplies southward. Of the twenty-two expedition members, ten survived the ordeal.

The commander's journal describes camera equipment brought aboard by J. J. Collins, a representative of the expedition's sponsor, the *New York Herald*.[2] Although photographs were taken, testimony by an officer suggested that Collins had failed to develop any of the glass plates successfully. None of the photographs taken are preserved in any government archive where other *Jeannette* material is stored. Naturalist Raymond Newcomb, after surviving the experience (Collins did not), moved to Salem where he provided sketches to illustrate newspaper accounts of the voyage. Did Newcomb carry the glass-plate negatives, or more likely these actual prints made in an onboard darkroom, out of the Arctic? Unfortunately, no descriptions in the commander's journal confirm either taking or salvaging these actual photographs, one of which appears in image 28. Whatever the details of their creation and preservation, these photographs remain as a testament to a rigorous voyage into dangerous and remote waters.

To be sure, maritime art typically incorporates subject matter associated with the ocean world. The most common maritime picture, whether a painting, a drawing, or a photograph, presents an image of a ship under way at sea. Other maritime pictures include a multitude of other vessel types, coastal views with lighthouses, harbors bustling with commercial activity, portraits of sailors, and even expansive seascapes that are unencumbered by coastline, people, or watercraft of any sort. Yet beyond the realm of pictures, there is a multitude of other objects such as scrimshaw, decorative ropework, and whimsies constructed inside bottles, that are all

broadly defined as maritime art. They are all reflections of the maritime experience from which they emerged, and often they are actually the products of sailors. The same definition holds true for pictures that are in one way or another inspired by the sea. The photographs presented on the following pages portray the immense variety of human encounters with the maritime realm. Images of codfish drying on wooden flakes and Chinese artists advertising their services for visiting mariners are each a product of distinct types of encounter.

Maritime photography was born and evolved over much of the nineteenth century as an unselfconscious discipline. Many practitioners were engaged in some pursuit related to seaborne activity, either as sailors, shipowners, or within a shoreside business that serviced the maritime trades, such as marine portraiture (image 24). Others were amateur historians creating documentary records of vessel types and harbor activity seen within a particular region. Photography has always shared a close relationship with travel. Indeed, in 1841, two years following the invention of the daguerreotype, Thomas Cook formed Cook's Tours. The rise of the tourism industry is essentially coincident with the rise of photography. The selection of images herein presents a wide range of subjects, defined by boundaries that are less exclusive than those set by others who have studied maritime imagery. Similarly, maritime photography is distinguished from other photographic categories not only by subject matter, but also by the special challenges and techniques that are by necessity employed in the creative process.

TECHNICAL CHALLENGES OF MARITIME PHOTOGRAPHY

In the earliest years, necessarily long exposure times, the uncontrollable variables of sunlight and reflection, and the movement of both clouds and water were enough to chase all but the most intrepid photographers back into their studios. Most photographs of ships taken before 1870 present them sitting stationary, either tied up to a pier, anchored, or moored, with the moving water leaving milky blurs around them. When the photographer used a relatively vacant background, the resulting ship portrait yielded a crisply defined profile, achieving an almost mystical effect of a ship divorced from all time and place (images 5 and 15). Such backgrounds were often difficult to arrange, as the photographer W. Parry noted:

> The picture of a ship with numerous others behind, with their forest of poles, spars, and rigging, looks confused and mixed up, producing a very unsatisfactory photograph, and one not at all likely to please. If you have the vessel moved a few feet into a more suitable position, you are treated as if you wanted the world moved, and are subjected to a large amount of abuse from self-important underlings.[3]

Naturally, images like the one he describes would not be selected for this volume, unless they had other distinguishing characteristics that set them apart. One option employed by many photographers is to repair inadequacies in their negatives back in the darkroom. Both in the nineteenth century and in much more recent times, it has been common to sandwich negatives when printing to insert missing elements of a composition. Stanley Rosenfeld described this process as commonplace when printing yacht photographs with his father.

> If the quality of the sky was uninteresting, we took the time to double-print a cloud in. We had a whole library of pictures of different clouds that we had taken from the boat or the dock with a low horizon with no trees or houses.[4]

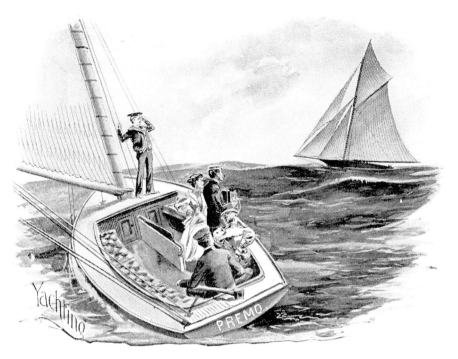

Figure 2. Image from an 1897 promotional booklet for the Premo camera, manufactured by the Rochester Optical Company.

The Rosenfeld family was certainly not the originator of this technique, since it was probably also used in the nineteenth-century image seen in figure 3 (steamer *Cambridge*) as well.

Shipwrecks have been a focus of attention from the earliest days of photography because they frequently occur near the shore where they are accessible to land-based artists. Being stationary, shipwrecks do not challenge the photographer in the same manner as do moving vessels. In general, wrecks have been photographed in disproportionate numbers relative to ships afloat. Obviously, shipwrecks evoke strong emotions among mariners and landsmen alike, and one need not have any special interest in ships to recognize that they are visually arresting.

Although ships may be stationary or moving, elements of nature are always fluctuating. A photograph can capture water in myriad variations, depending on wind, clouds, currents, waves, atmospheric and light conditions, and placement of the camera in relation to the light. Water can appear transparent or opaque, as reflective as a mirror or as solid as the ground. Some of the interesting presentations of water in these photographs were created by design, but others are the natural outcome of photographing under the given conditions with the available equipment. Sometimes a successful photograph emerges from a serendipitous combination of light, wind, and reflections, such as what likely happened with the box-camera photograph in image 53 of a yachting party. Most successful photographs, though, are created by photographers who can recognize and contend with, if not control, the multitude of variables that come into play in a fickle environment.

The number of variables increases when both the subject and the photographer's platform are moving vessels. By the 1880s, technology had developed briefer exposure times and lighter equipment, allowing dedicated photographers to get close to their subjects when they were at their most dramatic, moving rapidly

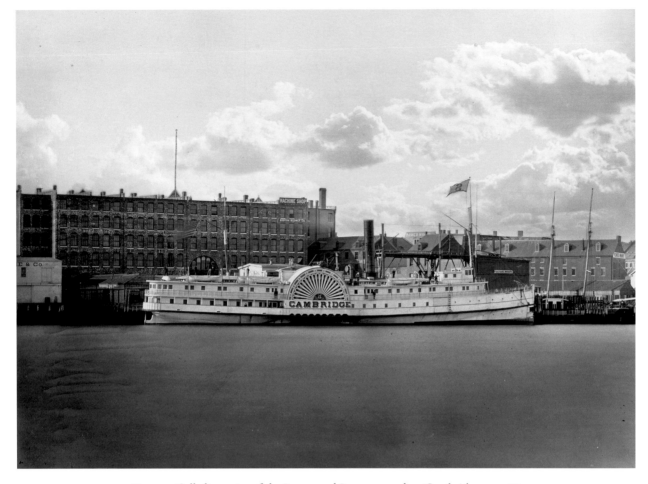

Figure 3. Collodion print of the Boston and Bangor steamboat Cambridge, *ca. 1885,*
by Augustine H. Folsom of Roxbury, Massachusetts.

through the water. In 1890, Parry commented that "photographing fast steamers from a small boat, on the open sea, is a very difficult operation, the perplexities of which can, to a great extent, be overcome by pluck and perseverance." Commenting further on technique, he noted that "the trick then is to aim at the ship and expose like lightning."[5]

A camera on a tripod will roll with a boat, but one held in the hand exposes the photographer to certain dangers. The daughter of yachting photographer Nathaniel Stebbins once remarked on watching "his rather small, spry figure balancing by the rail in the heaving bow of the boat, while he lifted the great camera to get his shot. Of course we held our breaths, for he couldn't swim a stroke."[6] With a fast boat of his own, of course, a photographer can race around the subject to frame it properly, to get side lighting that will define the shape of a hull and sails, or to backlight it so that the sun creates sparkles on the water.

CREATING PHOTOGRAPHS FOR COMMERCE AND ART

Practically by definition, maritime photography is an international art form. Every ship and mariner depicted in any photograph has one port that is home, but invariably, most working time is spent a great distance away.

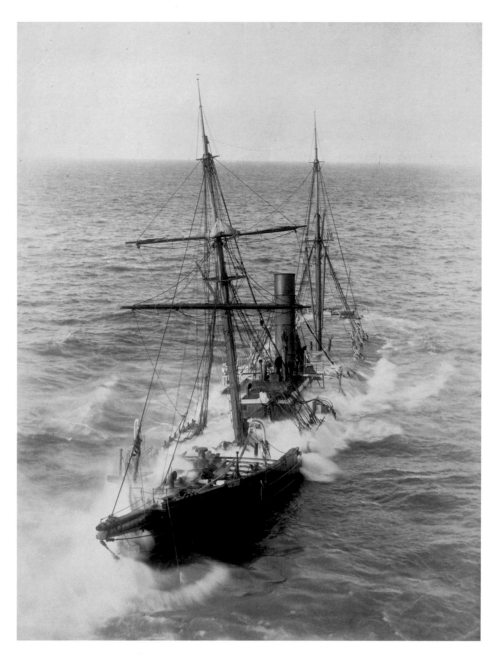

Figure 4. Albumen print of the wreck of S.S. Malta *at Land's End, 1889,
by Gibson and Sons of Penzance and the Scilly Isles.*

In the 1860s, commercial photographers specializing in ship portraiture were turning up in all the major ports in America, Europe, and Asia. Some, such as James Wallace Black of Boston, employed truly experimental and artistic techniques to fulfill their orders, but many simply presented vessel profiles and configurations in the most straightforward manner possible. Their customers were the builders, owners, insurers, crews, and passengers of the ships they photographed. Photographs produced in one port that were sold to itinerant mariners quickly made their way to other parts of the world. Today, the work of a professional photographer from an active Pacific port may be better represented in Salem, Massachusetts, where his customers returned home, than in that photographer's own town.

There were specific boundaries within which the commercial photographer practiced his craft. Parry, recognizing these limitations, noted that "Foreshortened bow or stern views are of little value (except from an artistic point), as the designer and builders of the vessel want to show the water line along the whole length of the ship."[7] There is not, however, always a distinction between fulfilling the demands of commercial clientele and creating art photography. For example, in the 1890s, the Moulton Photograph Company specialized in the sale of photographic reproductions of great European paintings, architecture, and sculpture that were considered suitable for decorating the modern home of the time. In their 1891 and 1892 catalogues, the selection of great works is augmented by a list of steamships that a client could also purchase. The catalogue does not make any distinction between the two groups, implying that the images served similar functions. Steamships were grouped alongside Gothic cathedrals and Renaissance oil paintings as being among civilization's greatest achievements.

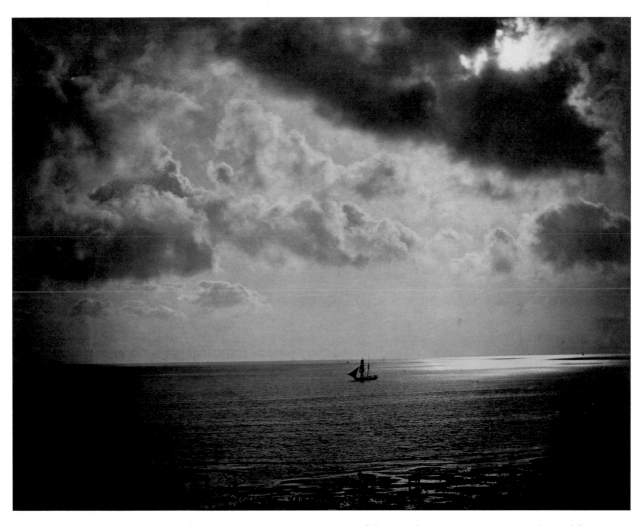

Figure 5. Brig upon the Water *by Gustave Le Gray, 1856. Courtesy of the J. Paul Getty Museum, Los Angeles, California.*

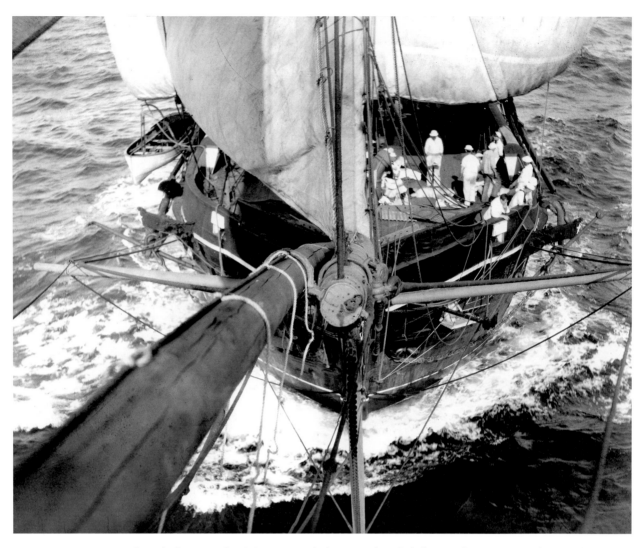

Figure 6. View from the bowsprit of U.S.S. Portsmouth *by an unidentified photographer, 1880–1900 (image 51).*

During the incipient years of the medium, creators of photographic images viewed their creations as fine art. Perhaps the first photographic seascape to become truly famous as a work of art was *Brig upon the Water* by the French artist Gustave Le Gray (1820–82). The photograph depicts an anonymous two-masted vessel at a great distance, with intense reflection of the mottled sky on a flat sea, emphasized by patches of sunlight and shadow. This image has appeared in books and exhibitions on the history of fine art photography for decades, most of which associate its importance with Le Gray's emphasis on the interplay of sea, clouds, and sunlight that anticipated later Impressionist interests and goals.[8] On technical grounds alone, the image was an achievement, since most photographs of that era, such as that in image 15, rarely attempted to capture a ship on the water that was not moored, on the ways, or tied up at a pier. The ship is sailing on the ocean, but the action is at a great distance. Hence, the effect of that motion is not a blurred image. Ever since W. H. Fox Talbot experimented with images of the seashore at Swansea, photographers have been fascinated with the complexi-

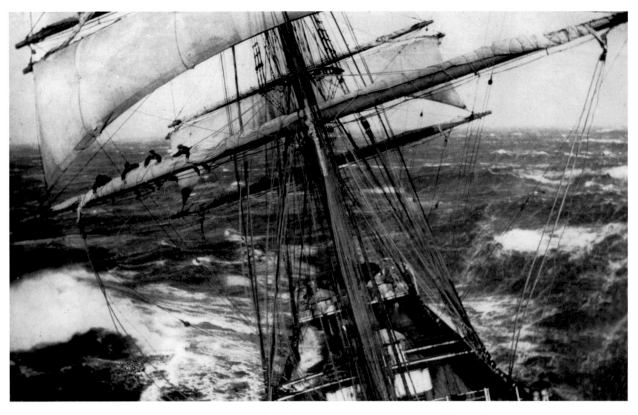

Figure 7. Gelatin-silver print of the bark Garthsnaid *from S.S.* Ionic *off Cape Horn, 1924.*
The photograph was taken by H. Ibbetson, chief steward of Ionic.

ties of marine photography. In essence, the challenge for them was to balance the brighter light from the sky with the subtler but localized reflections off the water, while maintaining an exposure brief enough to retain the shapes of waves and surf.

MARINERS AS PHOTOGRAPHERS

Although mariners would almost universally be classified as amateurs in the realm of photography, their creative work must be viewed in a category of its own. It is their combination of skills, primarily as mariners and secondarily as photographers, that makes them uniquely qualified to capture the subjects that compose their professional lives (figure 6). The majority of the interaction between the mariner and the photograph has been in the context of consumer, mostly in the form of portraits of family at home or of ships on which they served. On occasion, the skills and interests of the mariner were combined with those of the photographer in a single individual. In these all-too-rare instances, the creative process of photography is used as a technique for exploring a subject that is of great personal knowledge and significance to the mariner/photographer. Many of the photographs produced by so-called amateurs are more evocative of experience on the sea than those produced by the professionals.

[9]

For centuries, mariners have been writing journals, drawing and painting pictures, and crafting yarns to express to others their experience of the sea. Artistic abilities were considered desirable attributes in a professional mariner and were cultivated by navigational schools and naval academies. Whether on a voyage of discovery or commerce, a military campaign, or a yachting cruise, time spent on or near the sea invariably inspires a desire to convey to others the physical and emotional impact of the experience. The peril of near-death in a shipwreck, the curiosity inspired by an encounter with seal hunters on an arctic ice pack, and the sense of accomplishment and relief brought on by the arrival in an Asian port after an arduous Pacific crossing are all singular experiences that stand out above the more mundane aspects of life.

These are the seminal milestones by which the rest of our lives are measured and that give us pause to evaluate decisions made and reflect upon personal values. We have all had them, and whether disturbing or sublime, we have all struggled to convey the significance of these experiences to others. It is rarely during the course of everyday life that these events occur. Rather, they are the markers of special experiences that form the basis of personal memory. Many of us have felt inspired to record these situations in one fashion or another because we are aware of how fleeting that memory can be. In some, that inspiration manifests itself in the production of art that is a direct reflection of that experience.

Today it is easy for one on a ship to respond to this urge and record an event with an automatic thirty-five millimeter water-resistant camera with fast light-sensitive film. Ocean liner cruises are in a category with graduations and birthdays for their popularity as so-called "Kodak moments." We have all seen photograph albums of famous sights, with individuals or small groups posing in the foreground. Sometimes they appear stiff or sometimes happy, but often they are barely interacting with the architecture or monument with which they share the picture. Such moments are like record shots of one's life, and it almost does not matter whether the photograph is attractive to the eye or well executed. It serves its function by recording a rite of passage or by documenting a measurable phase of one's life—I have been to the Eiffel Tower, or I have seen the Grand Canyon.

Although a certain continuity may be seen in photographs of harbors and portraits of ships, an instantaneous photograph still represents a span of time with a distinct beginning and end. Whether a photograph represents six seconds or one-sixtieth of a second, the juxtaposition between stability and motion emphasizes an ephemeral moment as it is captured on film. Most bodies of water and the ships upon them are constantly in motion, and early on photographers recognized how this movement imparted a transient quality to an essentially two-dimensional picture.

At the dawning of photography, creative experimentation in both chemistry and composition was the domain of the wealthy and cultivated dilettantes who introduced the process to the world as an art form.[9] Unlike these amateur-scholars who acquired knowledge of the technology and advanced chemistry to practice their art to the most refined degree achievable at the time, a continuous stream of technical advances allows modern hobbyists to practice an accessible art. In many instances within this volume, the less-finished photographs taken by inexperienced photographers who did not try to control all of the variables to create a work actually capture the essence of the maritime experience that much better. With the availability of easy-to-use Brownie-type box cameras by 1890, the balance began to shift away from technical skill and toward nautical experience in taking the consummate maritime photograph.

Although not necessarily the one most likely to have a camera on hand, the mariner is the one most frequently best positioned to capture a dramatic photograph at sea. In the trying circumstances of severe weather, when seconds can mean the difference between safety and peril, mariners have occasionally shown the presence of mind to take the unusual photograph that conveys the immediacy of the experience. For example, while rounding Cape Horn during a southern winter gale in the early 1920s, the chief steward of the White Star liner *Ionic* secured a picture of the bark *Garthsnaid* as the vessel was passing under the stern of *Ionic* while running before the severe winds. Four crewmen are taking in sail from the main foremast yard, suspended beneath a fully reefed fore-topsail. At the moment of exposure, the yaw of the ship has left them suspended above nothing but the foaming sea (figure 7).

VIEWING AND INTERPRETING PHOTOGRAPHS

Since its inception, photography has been the most popular means of conveying visual information. There is no standard methodology from which to approach the interpretation of a maritime photograph, as one might use when viewing a portrait. Over time, perspectives on a maritime image can change dramatically. A historical photograph can serve as a signifier of a time in the distant past, emphasizing the observable differences between life then and now. Alternatively, it can transcend time and even place, presenting subjective experience of the sea with personal associations for the viewer. The images on the following pages present a range of different perspectives, attitudes, and intentions reflected through the lens of more than 130 years of interaction with the sea.

During the third quarter of the nineteenth century, photography was dispersed to every major port city across the globe, much of it in the form of commercial work. Any harbor active with sailing ships, steamers, or yachts seemed to support at least one professional who recorded their profiles as they entered or departed, and some major ports supported several in competition.[10] Just as art historians have largely, until recently, ignored the contributions of photography to fine art, academic historians have tended to ignore the information available in photographic archives. Photographs were utilized solely for the objective information they contained, as illustrations of points to be made in text. Any subjective information regarding opinion or perspective that could be gleaned through critical interpretation was simply ignored. Until the arrival of the digital age, we accepted as a truism that pictures do not lie. As image 47 illustrates, however, photographers have had the ability to manipulate the viewer and even to create false realities for quite some time. In this extreme example of darkroom manipulation, the photographer has imbued his image with an element of immediacy by adding a lifeboat crew to what was by then an abandoned wreck. As with the written word, all photographs distort reality toward the perspective of their creator. As the agent of expression, the photographer decides not only on the subject matter, but also the relationship between objects and the treatment of people within the composition.

Photographic compilations in the form of albums reflect an added layer of manipulation of the subject, since the images are observed in a prescribed order, influencing the viewer's experience. Both personally constructed photograph journals and professionally produced albums were designed to act as instantaneous triggers for those with memory of the experience. For everyone else, they act as multidimensional objects that provide a narrative structure with which to interpret that experience. An album of a yachting cruise might present

the harbors in the order they were visited, while an album created for a travel agent would provide a simulated tour of a luxury steamer.

Professionally produced albums are particularly suited to observing the impact of colonialism and imperialism in foreign lands, where the photographers intentionally focused both on subjects that highlighted the distinction between their place and home. Many images are infused with the attitudes of racially based colonialist superiority that may have sat comfortably with viewers of their times, but that today expose the biases of the photographer and intended customers. The photographs of China, such as that in image 21, were purchased as albums by Western merchants working in Asia. In addition, a limited selection of the same images could be obtained individually in Europe. Many of these pictures were intended to confirm a certain world view, but also were creating romantic memories about idyllic lands where influence of the "modern" Western world, when it appears at all, is a cultural benefit to the foreigners, and a commercial boon to the West.

Such provocative subject matter is actually of secondary importance in photographs created for purely aesthetic reasons. Pleasing tonal qualities and compositional elements are the primary measures of a successful art image, and photographs that were originally created for documentary or commercial purposes can today be appreciated strictly for their artistic value. When exhibited within a museum context, photographs experience a redefinition along artistic lines, highlighting qualities that may have previously gone unappreciated. Many of the photographs in this volume have been separated from their original documentation, with a subsequent loss of information regarding subject, photographer, and date. Though regrettable, the loss of such data allows these images to stand on visual grounds alone.

PHOTOGRAPHIC COLLECTIONS AT THE PEABODY ESSEX MUSEUM

The origins and early history of the museum's photographic collections are closely linked to cosmopolitan trends in mid-nineteenth-century America, which affected intellectual life on many levels. One of the earliest photographs in the museum collections is of the facade of East India Marine Hall captured in a whole-plate daguerreotype. Although the photographer is unidentified, the plate is marked with the stamps "Rich" and "Boston." Obediah Rich was a silversmith who in 1840 advertised in the *Boston Evening Transcript* that he made and sold daguerreotype plates on Court Avenue in Boston.[11] Although no daguerreotypists were advertising their art in Salem this early, itinerant photographers were already crisscrossing New England. The daguerreotype has been in the museum collections for many years, but unfortunately, poor condition prevents it from appearing either in this catalogue or the accompanying exhibition. Further evidence of Salem's close connection to the medium appears in literature. Nathaniel Hawthorne, in *The House of the Seven Gables* (1851), chose daguerreotypy as the profession for his protagonist, Holgrave. Thus, one of the first truly famous American photographers, though fictional, was created in Salem.

Photographic images of all varieties and technologies began entering the collections of the Peabody Essex Museum shortly after the medium was invented in 1839. These photographs joined the extensive collection of painted portraits that was acquired as documents recording the visages of prominent New England sea captains, statesmen, prominent citizens, and their families. As the medium developed, more casual outdoor subjects, such as gatherings of formal clubs and societies, civic organizations, police squads, fire clubs, street scenes, and landscapes were included.

The use of photography for historical documentation was first advocated by Lady Eastlake, and in 1883, the Boston Camera Club initiated a survey of historic architecture of New England.[12] About 1890, coincident with the Colonial Revival movement, the museum initiated a massive photographic survey to produce a synoptic record of the streets, houses, and waterfronts in Essex County towns and villages. In these photographs, the streets are essentially clear of people, carriages, and activities, no doubt because they were perceived as distractions by the photographers. They desired to recapture the distinctive appearance of traditional New England architecture in its original setting, as they believed it to have appeared at the birth of America. Removing these distractions yielded them once more free from the threat of the industrialization that was so rapidly reorganizing the urban New England landscape.

Beginning in the 1920s, the Marine Research Society of Salem, an organization devoted to preserving and disseminating information about early merchant sail, developed a vast collection of photographs of ships. Upon the demise of the society, the collection joined the museum's growing archive of vessel images that was primarily organized according to rig type, hull design, industry, and line of operation. This organizational technique was a product of the collection's perceived function: the ordering and advancement of knowledge about historic vessels through contemporary visual images.

Although photograph albums depicting Asian sights and scenes could be acquired in many ways, the albums held by the museum are among the finest anywhere. Several were the personal property of American merchants and officials who spent many years working in the treaty ports of Asia and who acquired intimate knowledge of the people and the landscape. They also had both the means and connections to acquire works of the very best Western and Asian photographers whose businesses catered to the interests of visitors and expatriates. Thomas Hunt was one such merchant, who owned a supply depot at Whampoa, a dry dock in Hong Kong, and maintained a houseboat in grand style. He returned from China with a substantial library that included numerous photograph albums. Other albums in the collection were acquired by William F. Spinney. Spinney lived in many different towns and cities in China during his stay of about twenty years, operating as a commissioner of customs for the Chinese government.

Building outward from this corpus of photographs, the collection was expanded with donations and purchases of numerous significant and large private collections. Collections of individual photographers came in both as glass-plate negatives, such as the Luke Collection (frontispiece), and as groups of negatives and vintage prints, many bearing the photographer's imprint, stamp, or signature. The more significant include over three thousand yachting photographs by Willard Jackson (image 72), twenty-one volumes of images by Ronald Stroud (image 96), and three thousand images by Paul Verkin, mostly of the port of Galveston (image 87). Smaller collections of prints and negatives by Edwin Lincoln (image 30), Nathaniel Stebbins (image 38), and Henry Peabody (image 52) portray lighthouses, seascapes, pleasure boats, the fishing industry, and countless other maritime themes.

Several large photograph collections that were compiled by dedicated maritime enthusiasts are in effect a quite comprehensive inventory of late nineteenth- and twentieth-century vessels, particularly steamships. The largest collection of this type was organized by Alan Deitsch, and includes 104 albums plus boxed prints totaling over one hundred thousand images of steam-powered vessels of all sorts, executed by an international array of known and unidentified photographers. Most of these collections were organized in a taxonomic fash-

ion by shipping line, rig type, means of propulsion, or flag of ownership. Hence, they are of value for those looking for an image of a specific ship, but are unwieldy for most other purposes. They also give the misleading appearance of being compilations of disinterested facts, but in reality are the products of selection and editing by both photographer and compiler.

The use of photography for its illustrative functions has resulted in a collection that has been perceived as purely documentary in value. Indeed, because of this perception, there are areas where there is a paucity of certain kinds of rare material that at one time would have been easy to acquire. For instance, Paul Strand photographed a figurehead in the museum collections for his book *Time in New England* (1950), but a print was never accessioned by the museum. Similarly, works by famous photographers lie unidentified in the collections, catalogued not by artist, but only on the basis of their subject matter. Several prints now identified as the work of art photographer Frank Meadow Sutcliffe (image 42) were found in the collections and catalogued only according to their subjects. The self-conscious fusion of maritime subject matter with fine art aesthetics constitutes an area with strong potential for future collecting, as well as opportunities for the further identification of existing "undiscovered" works of art.

THE SELECTION OF IMAGES

Whether utilized as contributions to art, history, or visual anthropology, photographs communicate on many levels simultaneously, and maritime photographs in particular speak to us about technical, emotional, and physical challenges encountered on the sea. In its broadest sense, then, maritime photography includes not only images of ships on the ocean, but also subjects that present the effects of this seaborne communication between disparate parts of the world. Like urban photography, which has been used to depict the process of growth and decay of cities, and Western photography, which has perpetuated the myth of a continent unmodified by prior human occupation, maritime photography has been used to promote a variety of political and social agendas.

Since this volume required the selection of roughly one hundred images from an inventory of over one million prints and negatives, specific photographs were included for a tightly defined set of reasons. Chosen not merely for informative subject matter with visually pleasing compositions, only a few of these images constitute premier examples of the more standard categories, such as ship portraiture, racing yachts, or vessels under construction. Instead, the majority of them warranted selection due to a particularly unusual, fresh, or novel image with a provocative perspective that set them apart from the vast majority of other pictures.

The following selection of images is not a pictorial study of maritime activity from the invention of photography to the present. It is not defined by regional or temporal parameters; nor are the photographs used as mere illustrations to build a story line. Rather, each photograph is an individual artifact imbued with information about human interaction with the sea. Although maritime photographs have been generated by such singular forces as commerce, military campaigns, tourism, and to advertise travel or the nautical industries, the allure of maritime imagery derives from the rich visual stories that emerge from the challenges inherent in humanity's confrontation with the elements.

Photographic Encounters:
A Selection of
Maritime Photographs
By Daniel Finamore
and Lyles Forbes

———⟨∞∞∞⟩———

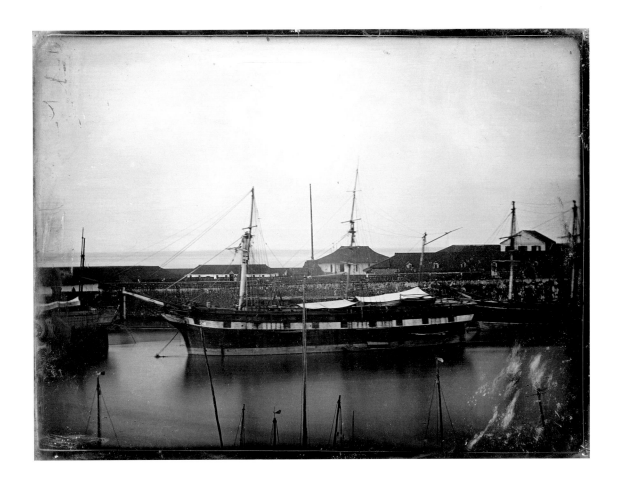

1. *Ship* Reindeer *in the Philippines, September 1850*

Unidentified photographer
Half-plate daguerreotype
Gift of Henry Mugford, 1899

A handwritten notation on the paper matting of this unusual Philippine daguerreotype reads "American Ship Reindeer of Boston in the River Pasiq, Manila, after being dismasted in a typhoon—(came in under Jury masts)."

The photographic process invented by Daguerre in 1839 remained popular until it was eclipsed by more versatile glass negative and paper printing techniques around 1860. Necessarily long exposure times made it difficult to record moving subjects, and few people in any part of the world experimented with creating daguerreotypes of ships.

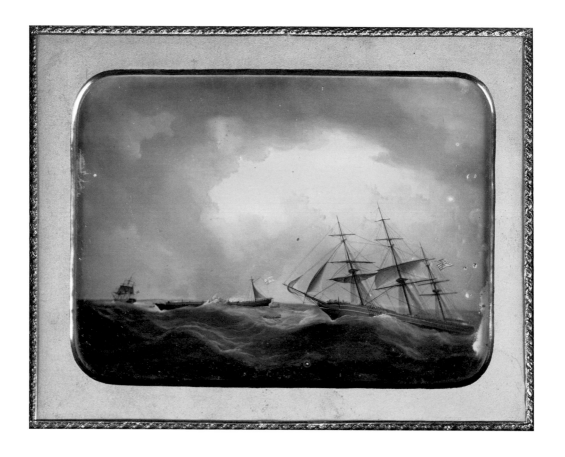

2. *The Ships* Antarctic *and* Three Bells *Rescuing Passengers on
24 December 1853 from the Steamship* San Francisco, *1854–60*

Mathew B. Brady's Studio
Half-plate daguerreotype
Gift of W. Ogilvie Comstock, 1958

Here, the Brady studio has produced a daguerreotype of a marine painting by James E.
Buttersworth. Artists frequently produced photographs of their paintings to increase profit
from their work. This one might have been commissioned by someone involved in the incident.
In addition, Nathaniel Currier produced lithographs of this popular painting; the whereabouts
of the original are unknown.

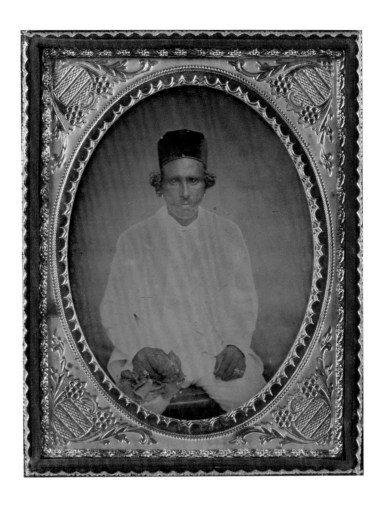

3. *"Old Bustie," circa 1855*

Unidentified photographer
Quarter-plate daguerreotype
Gift of Pauline Fisher Smith, 1985

The steam frigate *Powhatan* called at the island of Mauritius
while on a cruise in the Indian Ocean between 1857 and 1860.
The American consul there, George M. Farnham, gave the
officers of the ship a set of daguerreotype portraits of his family,
including this meticulously colored one of his houseman.

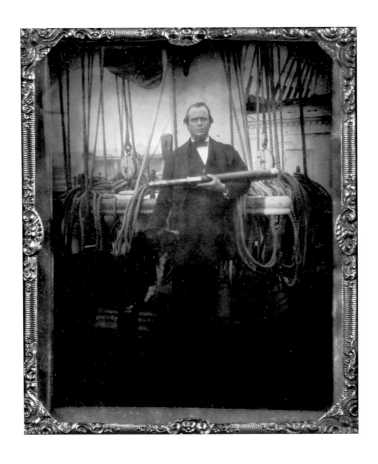

4. *Ebenezer Hathorne, 1850–58*

Unidentified photographer
Ambrotype
Gift of the Whipple family through Everett Whipple, 1938

Ebenezer Hathorne (1789–1858) only served two years before writing to the secretary of the Navy in December 1810. He states that since it would "be out of my power to do the duties incumbent on me as a midshipman, on account of my being invariably sick when at sea in rough water, I am compelled to resign my station as midshipman in the U.S. Navy."

Later in life, however, he returned on board a ship to have his portrait taken along with his dog.

5. *Steam Frigate at Sea, circa 1860*

Unidentified photographer
Quarter-plate daguerreotype
Museum purchase, 1983

The daguerreotypist evidently desired an image of a vessel at sea, since there is no wharf, anchor chain, or mooring line visible. The frigate is not actually underway, however, since no steam or bow wave can be seen. The plate is marked "Scovill Mfg' Co. Extra," a leading American platemaker based in Waterbury, Connecticut.

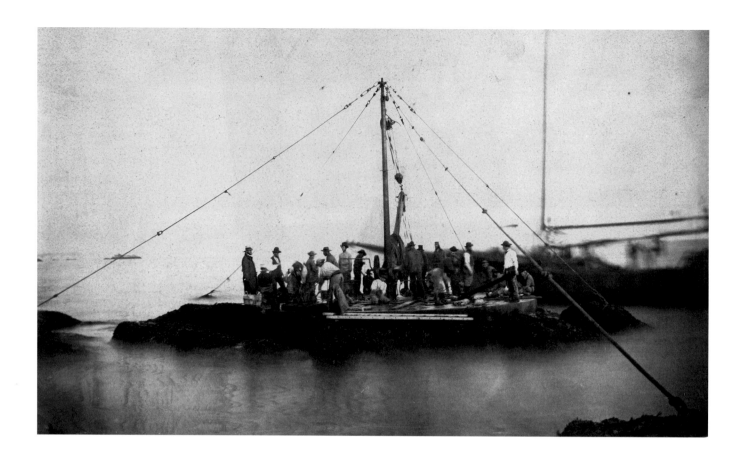

6. *Construction of Minot's Light, Boston Harbor, 1857*

Unidentified photographer
Albumen print
Gift of the Bostonian Society, 1957

The construction of Minot's Light in Boston's outer harbor began in July of 1855 to replace an earlier iron lighthouse that had been destroyed during a gale in 1851. This early paper print shows workers laying the base of the granite structure in 1857. The work crew had spent the previous two summers cutting the foundation hole in the ledge that was only exposed during extreme low tide. The long photographic exposure time created a blurred image of the moving sloop behind them. The photographer and bulky camera equipment were positioned on another small outcropping of the barnacle-encrusted ledge.

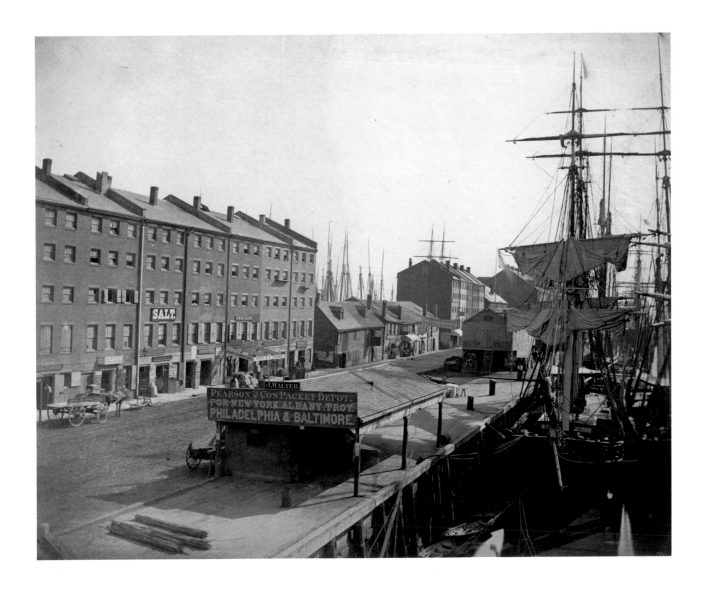

7. *Long Wharf, Boston, circa 1860*

Unidentified photographer
Albumen print

Long Wharf originated as a fortified breakwater in the 1670s, extending twenty-two hundred feet out into the harbor. The more substantial buildings seen here were constructed in the eighteenth century. About the time of this photograph, filling between Central and Long Wharves effectively enlarged Boston proper while diminishing the wharves. The salt houses along the wharf serviced the fishing industry.

8. *Ship* Ring Dove *of Boston at the Chincha Islands off Peru, 1862*

Unidentified photographer
Albumen print
Gift of the Bostonian Society, 1957

In the later nineteenth century, sea bird guano was a highly sought-after commodity for fertilizing depleted soils. Vessels engaged in this trade sought out remote and preferably uninhabited islands where birds had nested undisturbed for centuries, building up major deposits. *Ring Dove* has maneuvered in close to the wharf and prepares to take on a cargo.

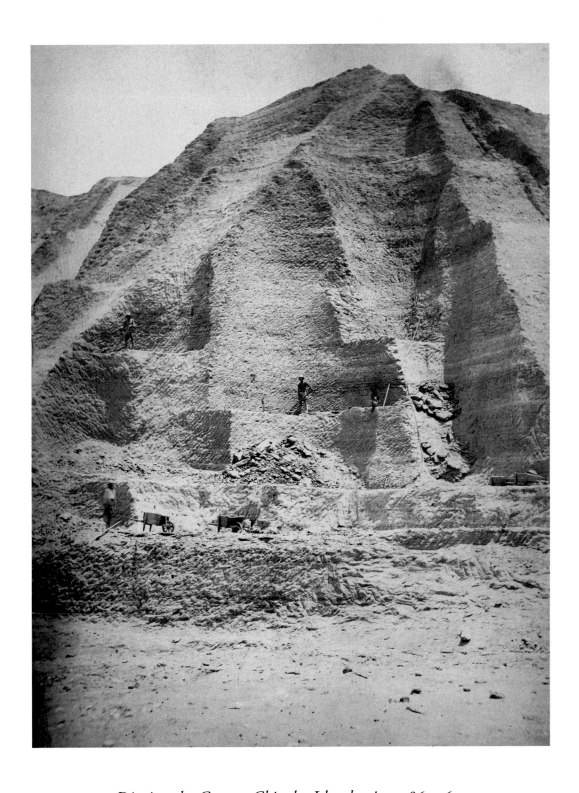

9. *Digging the Guano, Chincha Islands, circa 1860–65*

Unidentified photographer
Albumen print

In the early years of the guano trade, crews of ships would go ashore and harvest it themselves. Later on, they purchased the fertilizer from workers who had moved to the islands.

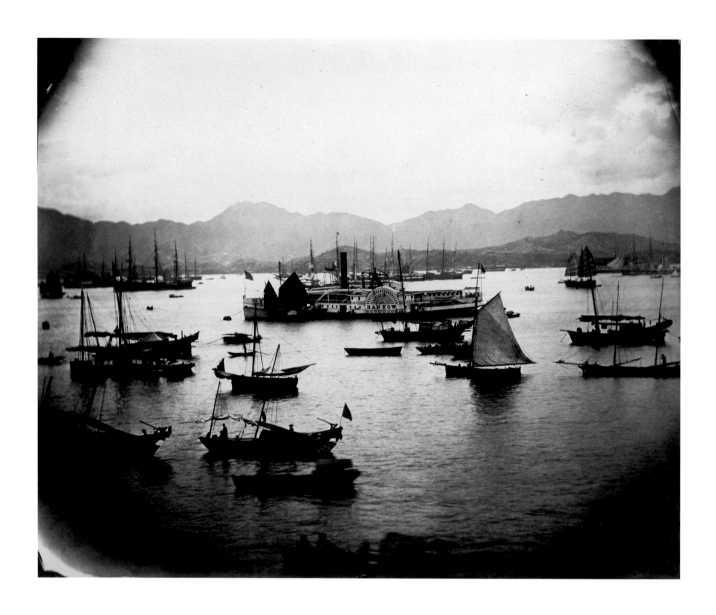

10. *Steamer* Hankow *at Hong Kong, circa 1862*

Unidentified photographer
Albumen print

This unusually early China photograph captures sunlit mountains, reflections on water, and the silhouettes of Western and Asian watercraft in a bustling Hong Kong Harbor. The photographer centered the composition on the white hull of the river steamer *Hankow* off-loading cargo. The *Hankow* was built in 1860 for the firm of P. S. Forbes and Company and arrived in Hong Kong in August of 1861. She was under contract to Russell and Company for service between Hong Kong and Canton. She burned at Canton in 1865.

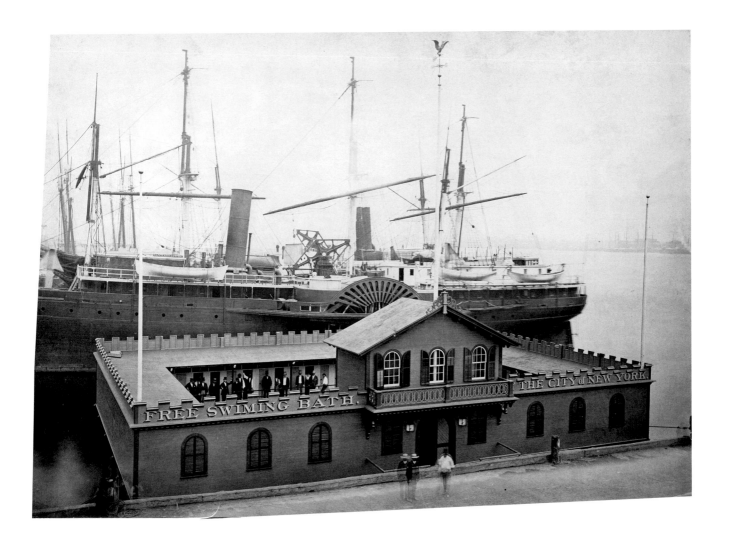

11. *Swimming Bath, New York City, 1861–65*

Unidentified photographer
Albumen print
F. B. C. Bradlee Collection

Floating bathhouses were tied up to piers at various points around Manhattan for the free
use of residents. This bath occupied space alongside shipping berthed in the East River.
Behind the bath is the sidewheel steamer *Santiago de Cuba,* built in 1861.

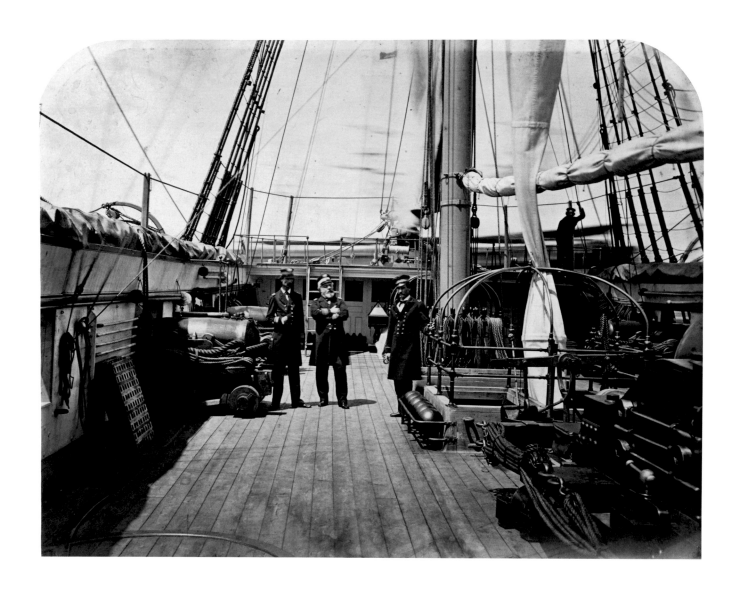

12. *Commander W. A. Parker and Officers on the Deck of U.S.S.*
Tuscarora, 1863–65
Attributed to the studio of Mathew Brady
Albumen print

The new medium of photography brought the Civil War home to people in a fashion that was
not possible in previous American wars. Portrait photographs of generals and admirals were ex-
tremely popular and could be ordered from catalogues. Deck views of warships, however, were
less common.

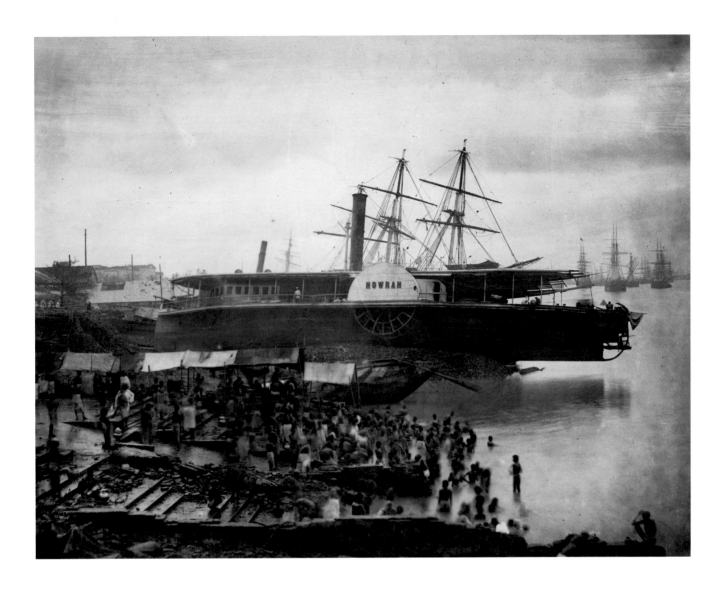

13. *Aftermath of the Bengal Cyclone, 5 October 1864*

Pearson and Paterson
Salted paper print
Gift of Charles H. Taylor Jr., 1933

At 1:00 p.m. on 5 October 1864, a massive cyclone struck in the vicinity of Calcutta, India. In its wake, over one hundred ships were damaged or destroyed. The steamer *Howrah* was cast up on a brick jetty and was a total loss. Of the incident, an English gentleman wrote to a friend that "Hardly a ship has escaped unharmed, most have sustained frightful injuries, some have foundered altogether, and many are hopeless wrecks. Such widespread ruin never overtook a port before, or involved so many splendid ships in one common fate."

Residents Pearson and Paterson produced a set of fifty photographs of the aftermath, which the Bengal Photographic Society believed would "say more in Europe than any written description of this terrible hurricane."[13]

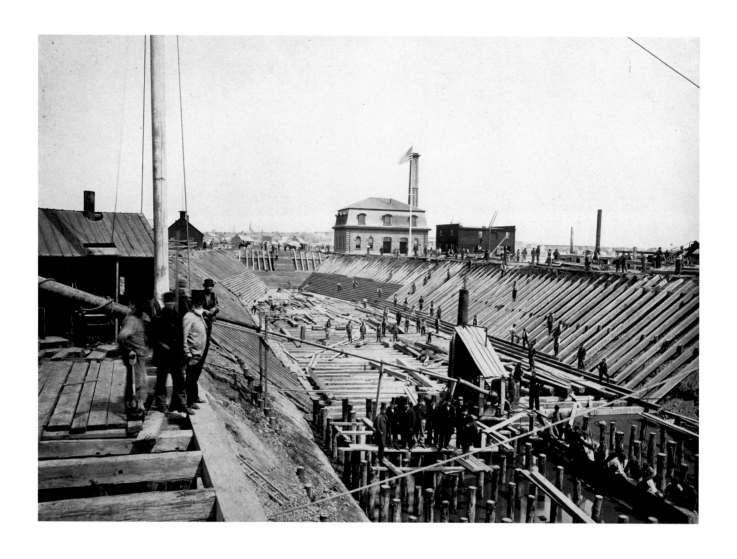

14. *Erie Dock, Brooklyn, New York, 1864–66*

Andrew Jackson
Albumen print

In 1801, the government opened the New York Navy Yard, buying an existing commercial shipyard. The yard was at its liveliest during the Civil War when fourteen large vessels were launched, and over four hundred commercial vessels were fitted out as cruisers.

On the reverse of this photograph is a stamp, initialed by the photographer, indicating payment of the tax on photography levied between 1864 and 1866.

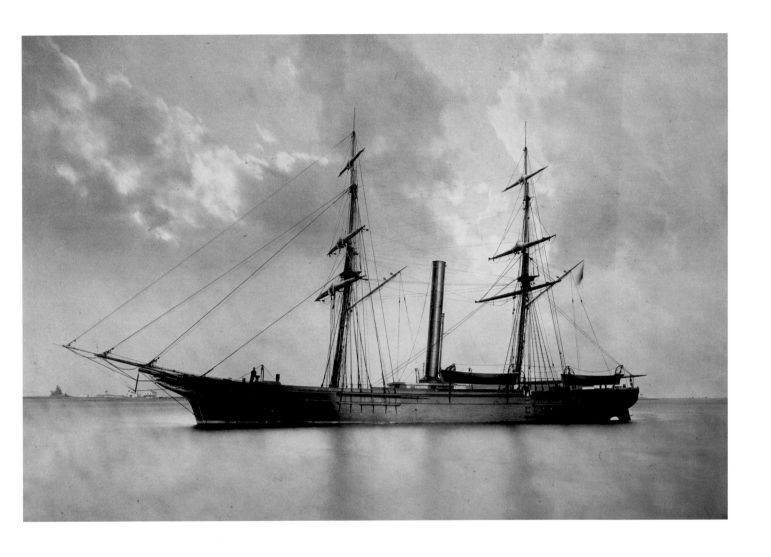

15. *U.S. Revenue Steamer* Levi Woodbury, *circa 1865*

James Wallace Black
Albumen print
F. B. C. Bradlee Collection

After abandoning daguerreotypes for the more versatile paper-based photography, James Black emerged as the preeminent commercial photographer in Boston. The black hull of the newly launched *Levi Woodbury* reflects the sun, while the masts and smokestack of the stationary ship are reflected on the moving ocean. After a long career in the revenue service, the steamer was sold in 1915 for use in the first motion picture film portraying the loss of the *Titanic*.

16. *Turret of* Royal Sovereign *after Shots from* Bellerophon, *1866*

Unidentified photographer
Albumen print

One of the most significant changes in warship design occurred with the mounting of the biggest guns on turntables, protecting them and their operators with armored turrets. In 1862, the British three-decker *Royal Sovereign* was refitted to include four such turrets. Action between ironclads during the American Civil War prompted the British to test the effectiveness of their own wooden constructions. H.M.S. *Bellerophon* fired three shots from a distance of two hundred yards into the turrets of *Royal Sovereign* causing the damage seen here, which was considered light.

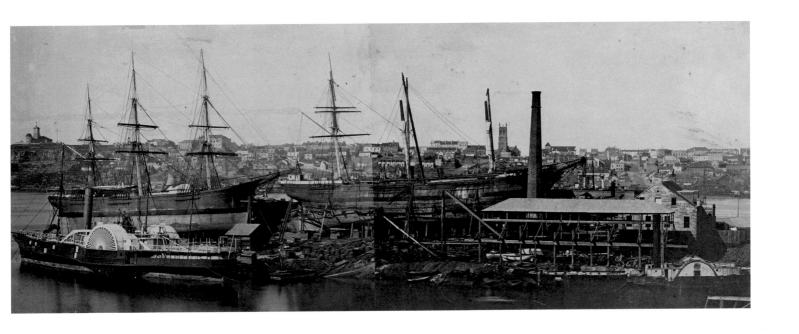

17. *Pyrmont Patent Slip, Sydney, John Cuthbert Proprietor, with the Ships*
Castilian *and* King Philip *Hauled Up for Repairs, circa 1867*

Freeman Brothers Gallery of Photography
Albumen print

John Cuthbert ran a shipbuilding yard on the western shore of Miller's Point in Darling Harbor, Sydney, Australia. Cuthbert's business built and repaired commercial, naval, and recreational vessels and employed more than three hundred people. This early photograph of an Australian shipyard was produced with paper from two wet-plate glass negatives mounted side by side to form a panorama.

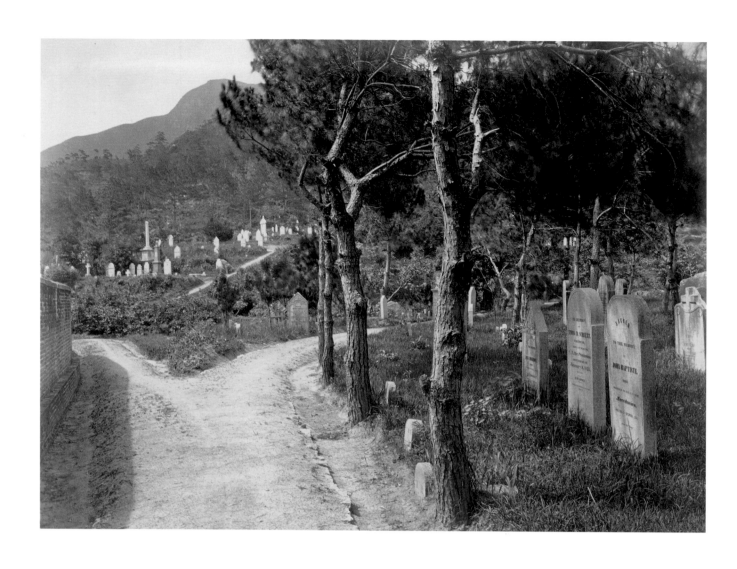

18. *Cemetery, Happy Valley, Hong Kong, 1865–75*

Unidentified photographer
Albumen print
Gift of Mrs. W. F. Spinney, 1923

Long voyages meant that a sailor might not be buried alongside his family. Burial at sea was commonplace, but if near a port, remains were interred in a local cemetery. Merchants, expatriates, and transient sailors are buried in this Western cemetery. The grave markers that are visible are for mariners from the United States Exploring Expedition and Commodore Perry's expedition to Japan.

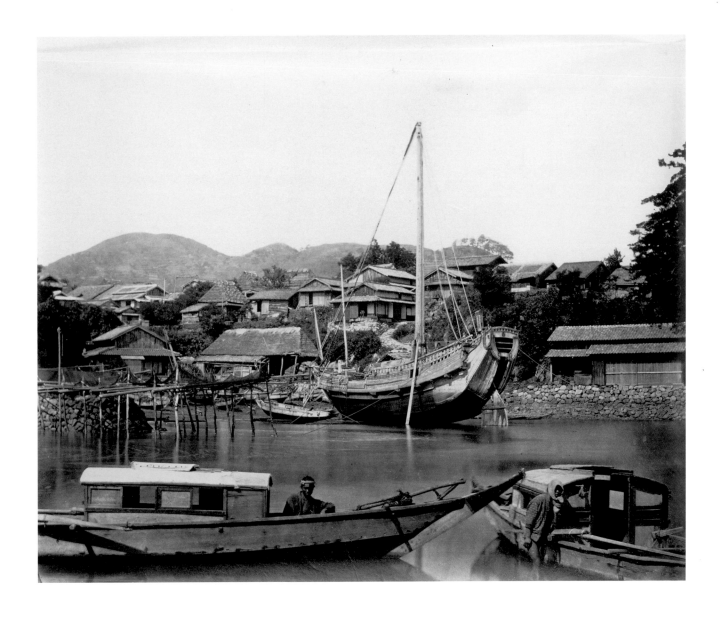

19. *Group of Japanese Junk Boats in the Canal, Japan, 1867–68*

Felice Beato
Albumen print
Museum purchase with funds donated anonymously

Only fifteen years after Japan was opened to the West by Commodore Perry's naval fleet, Felice
Beato felt inspired to record traditional Japanese culture, already being drastically transformed by
Western influences.

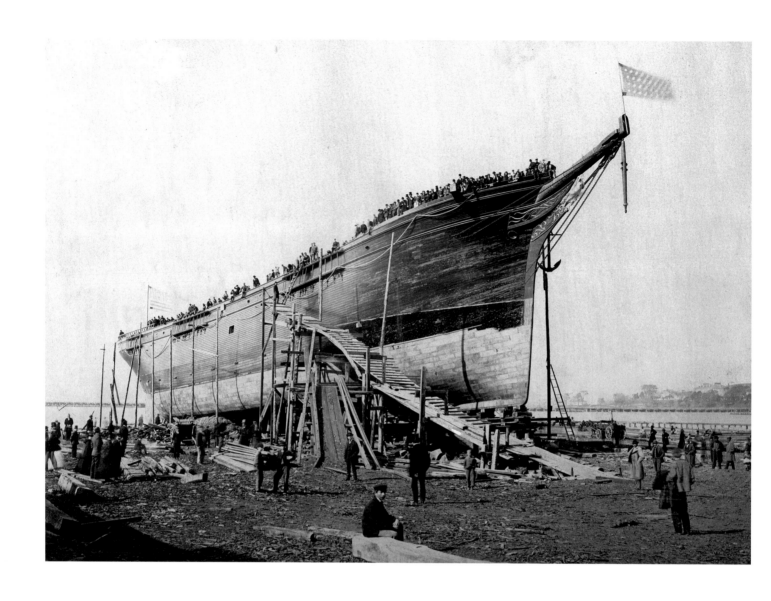

20. Glory of the Seas *on the Ways, October 1869*

James Wallace Black
Albumen print

By 1869, Donald McKay had built thirty-two clipper and packet ships in his East Boston yard, including several of the world's most famous vessels. *Glory of the Seas* was the final ship built before McKay went bankrupt. McKay appears at the center of the photograph wearing a top hat.

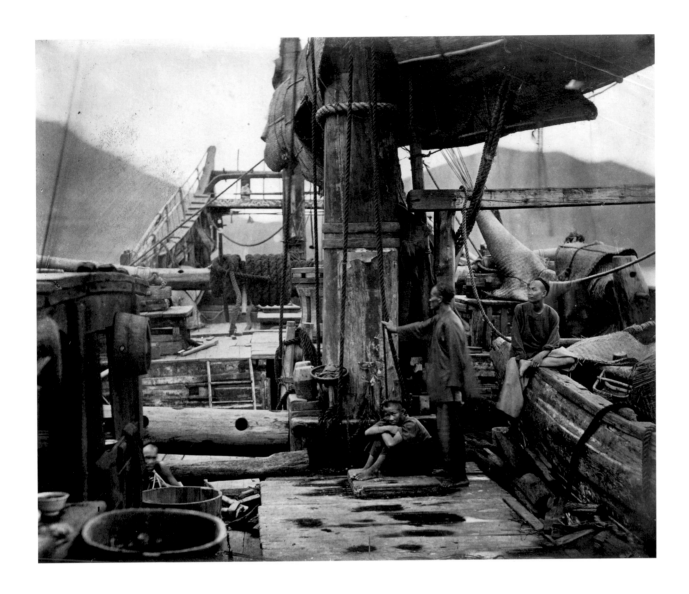

21. *Chinese Junk, 1868–72*

John Thomson
Albumen print
Gift of George Jeffries Harrington Jr., 1993

Many hazards can impede the maritime photographer. This instance involved an unwilling crew. The photographer John Thomson related the story of how he climbed aboard the junk from his boat and encountered the crew, who were about to hoist sail and get under way. "Suddenly, they forsook their work, confronted us with angry gestures and threatened to bar our advance." After some negotiation and a consultation at their onboard shrine, they assisted Thomson with his photograph.[14] Thomson interpreted their distaste for being photographed as superstition and ignorance. More likely, it was a reaction to their vulnerability as to how their lifestyle would be manipulated by the photographer or interpreted by a distant viewer. The album containing this photograph was originally owned by Henry Upham Jeffries, a partner in Russell, Sturgis and Company.

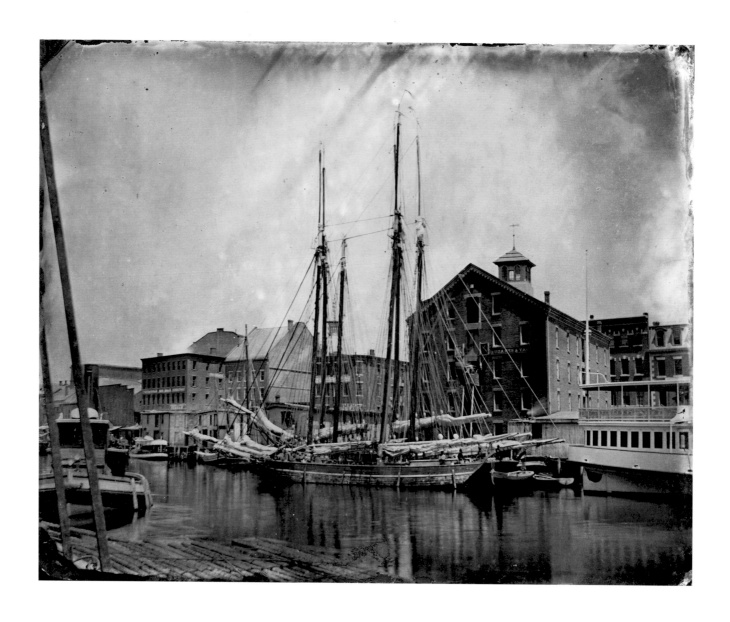

22. *Schooners in the Providence River, Rhode Island, 1860–70*

Unidentified photographer
Whole-plate tintype

Two coasting schooners are tied up at the warehouse of Day and Sprague, dealers in flour and grain. Farther down South Water Street is the Providence Blank Book Manufactory. Like daguerreotypes, tintypes record their images in reverse.

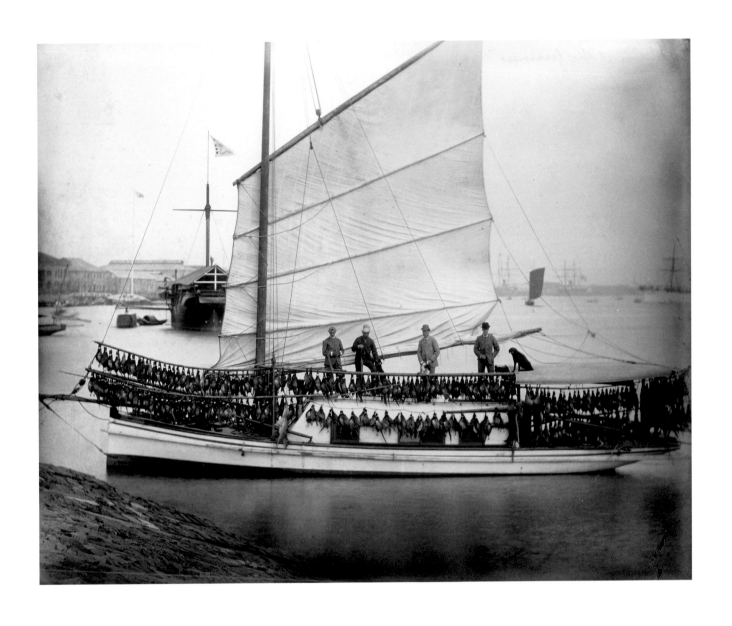

23. *Return of the Gunners, Shanghai, circa 1870*

Unidentified photographer
Albumen print
Gift of Laura Revere Little, 1944

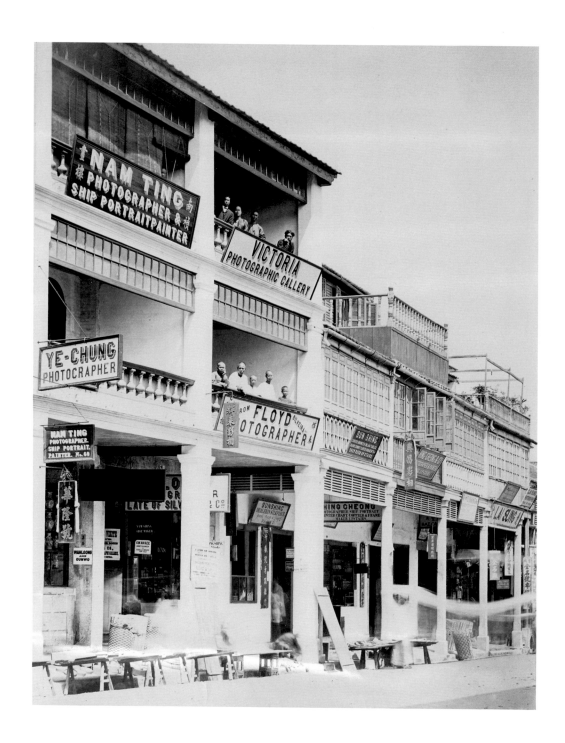

24. *Photographers' Studios, Queen's Road, Hong Kong, 1865–74*

William Prior Floyd
Albumen print
Gift of Mrs. W. F. Spinney, 1923

The manner in which photography was marketed to Western visitors is apparent in this Hong Kong street view, where photographic and painted ship portraits are advertised by both Chinese and British artists. The photograph appears in an album called "Hong Kong Views," produced by the Victoria Photographic Gallery.

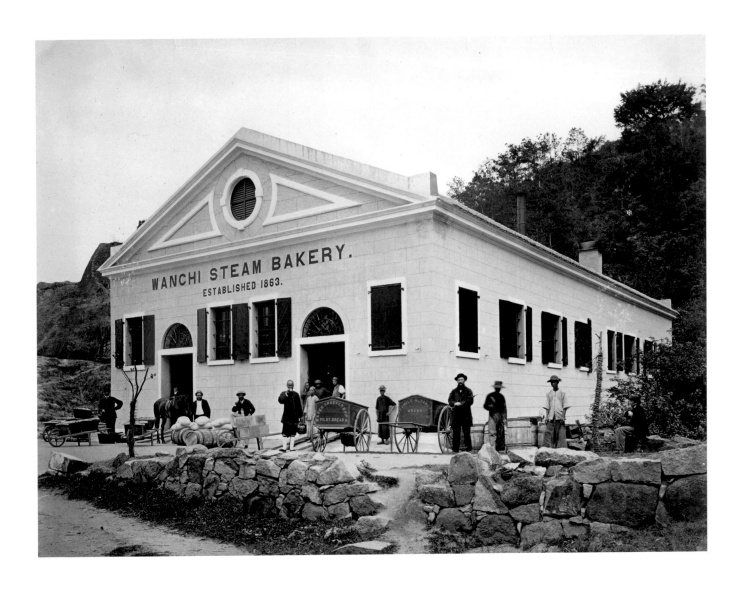

25. *Wanchi Steam Bakery, Hong Kong, circa 1875*

Attributed to John Thomson
Albumen print
Gift of Mrs. W. F. Spinney, 1923

This photograph comes from an album displaying views of businesses, houses, and recreations of interest to Westerners in nineteenth-century Hong Kong. The Wanchi Bakery supplied bread to the international community, not only for consumption locally, but also aboard ships. Ship's biscuit, or hard tack, was baked until dry and packed in large barrels so that it would keep on long voyages.

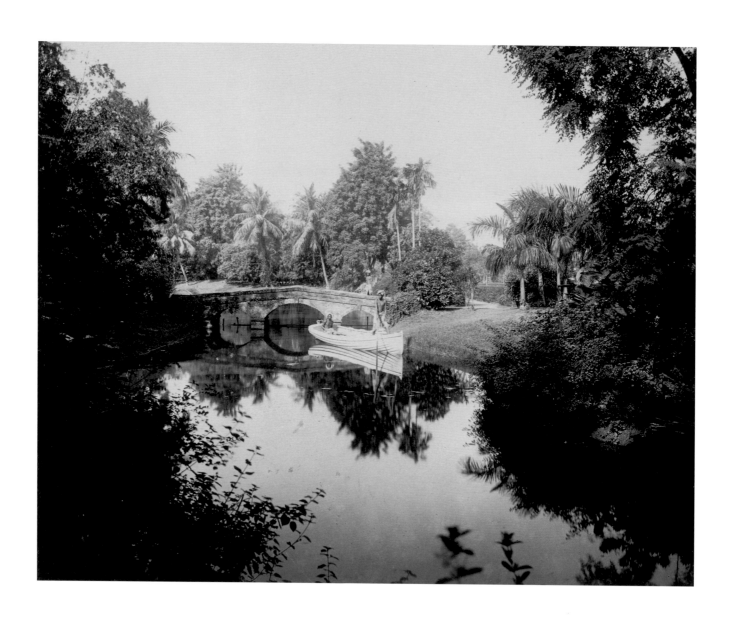

26. *Eden Gardens, Calcutta, India, 1870–80*

Johnston and Hoffmann
Albumen print

Naturally, the designer of the garden included a serene lake, providing an opportunity for recreational boating in his version of Eden. Although the boatmen are Indian, the craft is distinctively European in design.

Eden Gardens was named for the seven sisters of Baron Eden, Earl of Auckland, who was later first lord of the admiralty.

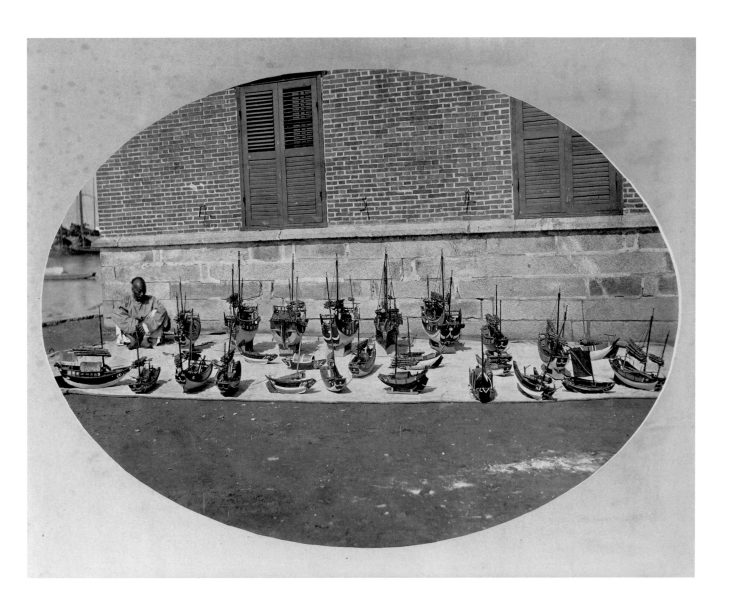

27. *Native Craft of Amoy, Models for the Paris Exhibition of 1878*

Unidentified photographer
Albumen print
Museum purchase, 1930

Arts and industries from all nations were exhibited at the popular world's fair held in Paris.
The models shown here were displayed in China's pavilion, amidst a fair that emphasized art,
ingenuity, and engineering.

28. *In the Ice, 1879*

Attributed to Jerome J. Collins
Albumen print
Gift of Walter Muir Whitehill, 1946

This photograph, a dramatic portrayal of ships caught in polar sea ice, is one of five in the museum collections augmented with a notation "Salvaged by Raymond L. Newcomb naturalist & taxidermist from Stmr Jeannette." In an attempt to sail farther north than anyone had previously done, a U.S. naval expedition in the *Jeannette* departed from San Francisco in 1879 and headed through the Bering Strait. By September, the ship was frozen into the ice, where she remained until June 1881, when she was finally crushed. Of the twenty-two people on board, twelve died. Many relics from the voyage are held in various government archives, but there are no known photographs.

The association of this photograph with the expedition remains a mystery. The commander's journal mentions the taking of pictures. In a formal inquiry that followed the disaster, however, one crewman testified that no decent photographs were produced because the expedition photographer Jerome Collins (by then dead) had brought along the wrong equipment. Newcomb, who survived the ordeal, carried a Ross gull out of the Arctic, now preserved in the Smithsonian Institution. Whether he also carried photographs printed aboard the *Jeannette* will probably never be determined definitively, nor precisely when this picture was taken.

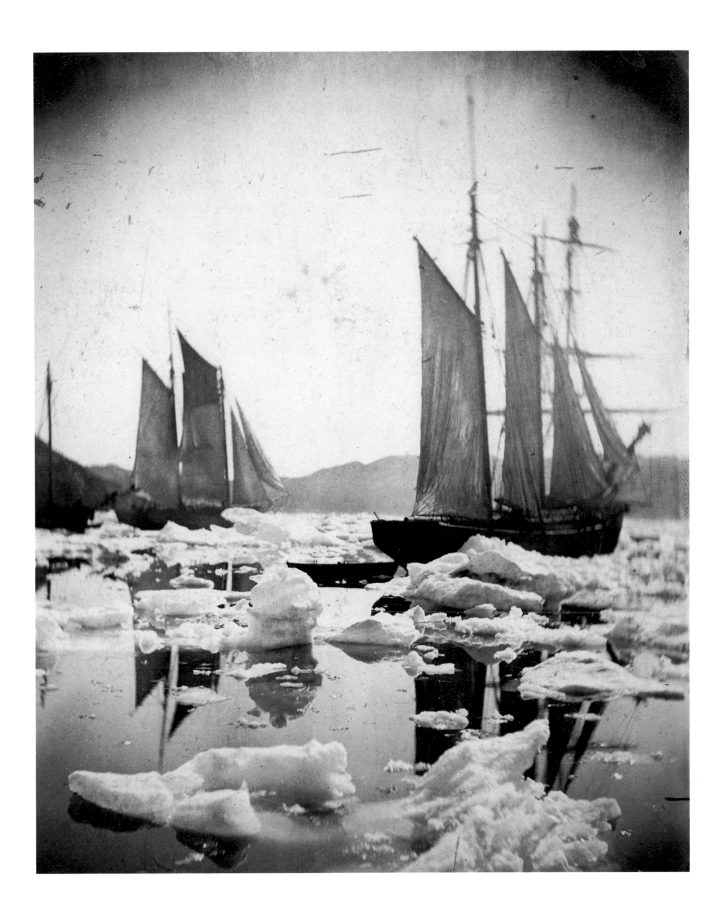

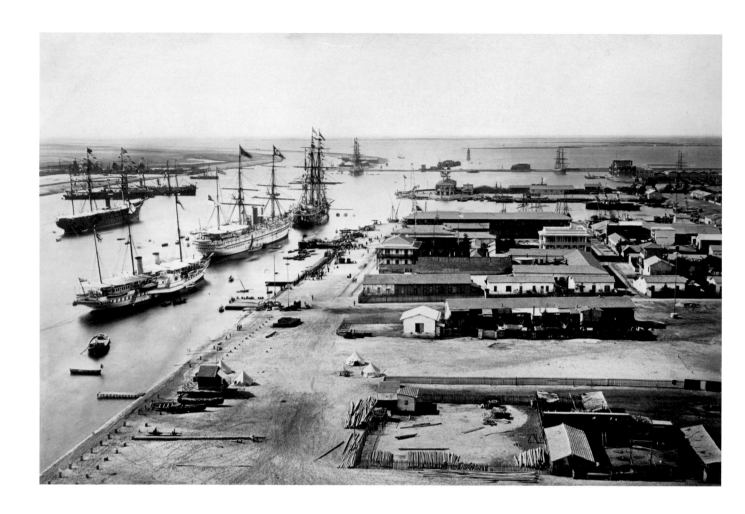

29. *The Arrival of the Prince of Wales in Port Said, October 1875*

Comianos et Sarolidis
Albumen print
Edward S. Clark Collection

Queen Victoria's eldest son, later Edward VII, called at Port Said, Egypt, while enroute to
India in 1875. The photograph produced to commemorate the visit uses an open composition
bathed in bright light and an extremely high viewer angle that extends the view outward to the
distant horizon and laterally beyond the edges of the picture.

30. *Cockpit of* Dauntless, *circa 1880*

Edwin Hale Lincoln
Platinotype
Edwin H. Lincoln Collection

At the time Lincoln created this photograph, *Dauntless* was one of New York's most famous
yachts. A veteran of the first international transoceanic race, she was also owned for a short
time by the flamboyant yachtsman James Gordon Bennett, owner of the *New York Herald.*
Lincoln also photographed other famous yachts, including *America,* before turning his atten-
tion to studies of nature.

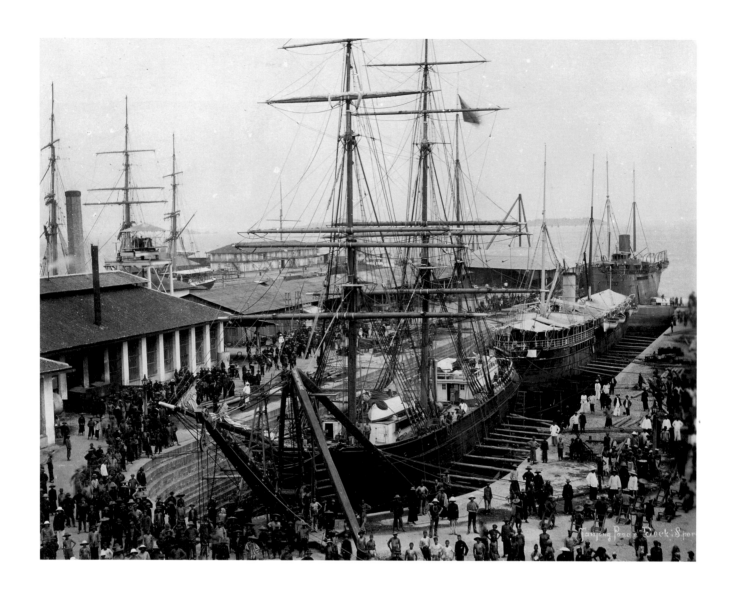

31. *Tanjong Pagar Dock, Singapore, circa 1880*

G. R. Lambert and Company
Gelatin-silver print
Gift of Dr. Charles Goddard Weld, 1908

The viewer looks out over a crowd of Malaysian workers at the Victoria Graving Dock, the first of two drydocks built by the Tanjong Pagar Dock Company.[15] This image was taken by a Singapore commercial photographer, most likely to promote business in the port. Competition between ports of Southeast Asia for contracts for vessels needing repair, such as this American bark, was as keen in those days as it is today.

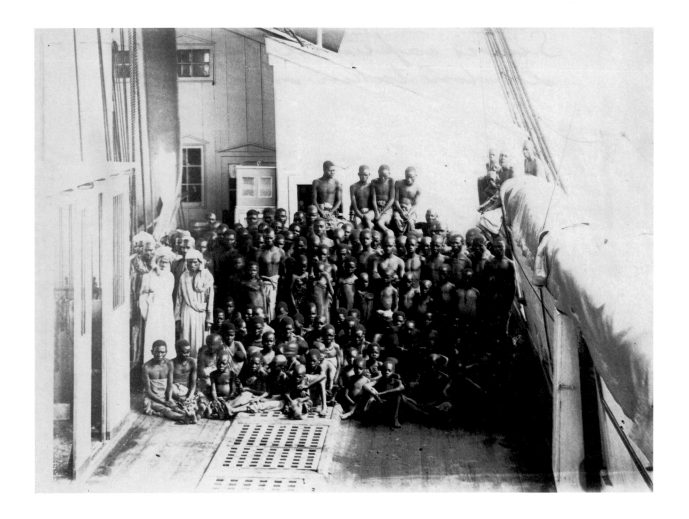

32. *Slaves Captured by H.M.S.* London, *Zanzibar, 1876–84*

Unidentified photographer
Albumen print
Gift of Ruth R. Ropes, 1948

Long after the abolition of slavery in the countries and colonies of the New World, an illegal slave trade continued along the coast of East Africa. To suppress this trade, the seventy-two-gun H.M.S. *London* was stationed as a depot ship off the island of Zanzibar for ten years while her boats cruised the coast and waters for slaving dhows. In July of 1877, Lieutenant Mathews wrote a letter to his mother from the ship:

"I returned a few days ago from a cruise of 26 days having captured three slave vessels, and expect to leave here tomorrow for a few days to try and track one out that I have information about. Tracking them is rather like what children play—Hide and Seek as we sometimes have to go 40 or 50 miles out of our way from the place at which we expect to find them. . . . [The slaves] are in the most awful state when we get at them; just stewing together, packed like herrings, and one mass of small-pox; many often dead; and they and the living cooped up as tight as they can fit in. The slave dealers are an ugly lot. You have to be ready to put a bullet through them at all times."[16]

This photograph comes from an album owned by Edward D. Ropes Jr., an American businessman and importer of East African ivory. Photographs documenting any aspect of the African slave trade are rare, particularly shipboard scenes.

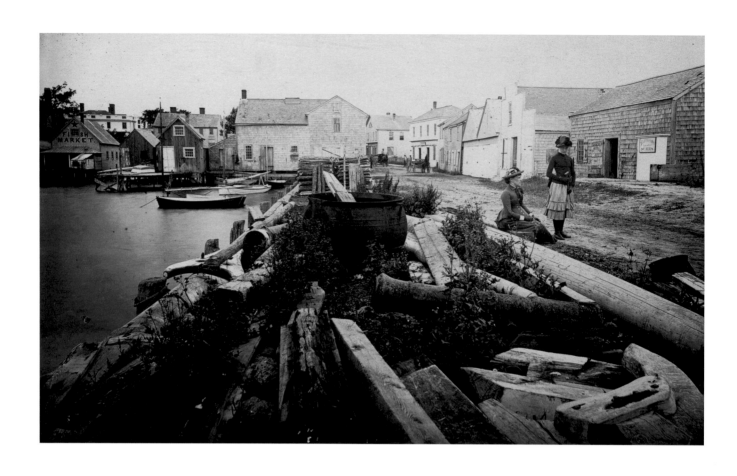

33. *Wharf at Edgartown, Martha's Vineyard, Massachusetts, circa 1880*

Baldwin Coolidge
Gelatin-silver print
Gift of the Society for the Preservation of New England Antiquities, 1974

By the time of this photograph, Edgartown's whalers had become nearly extinct. During the
Civil War, the raiders *Alabama* and *Shenandoah* decimated Edgartown's whaling ships. After
rapid rebuilding, thirty-three vessels were crushed in arctic ice in 1871, a blow from which
the fleet never recovered. Memorializing the once-great industry, the photographer records
the remnants of whaling activity left to rot on the wharf, including a trypot, cannon, spars,
and masts.

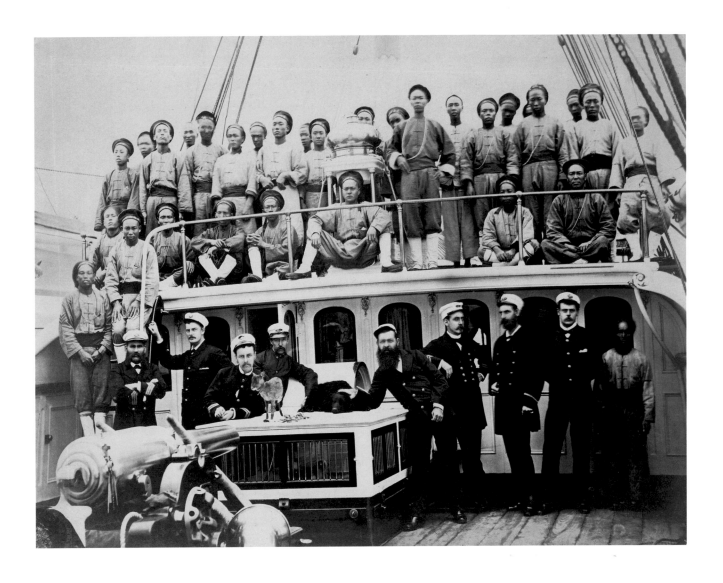

34. *Officers and Crew of the Cruiser* Ling Feng, *1882*

Unidentified photographer
Albumen print
Museum purchase, 1930

In 1854, the United States, England, France, and China formed the Foreign Inspectorate of Customs to help manage duty payments and reduce smuggling in the Chinese treaty ports. Although composed of foreigners, the institution was under the ultimate jurisdiction of the Chinese government. Patrol ships purchased from European nations were manned with Western officers and Chinese crews. The photograph is from an album purchased in China by William F. Spinney, who worked for the Imperial Majesty's Customs Service.

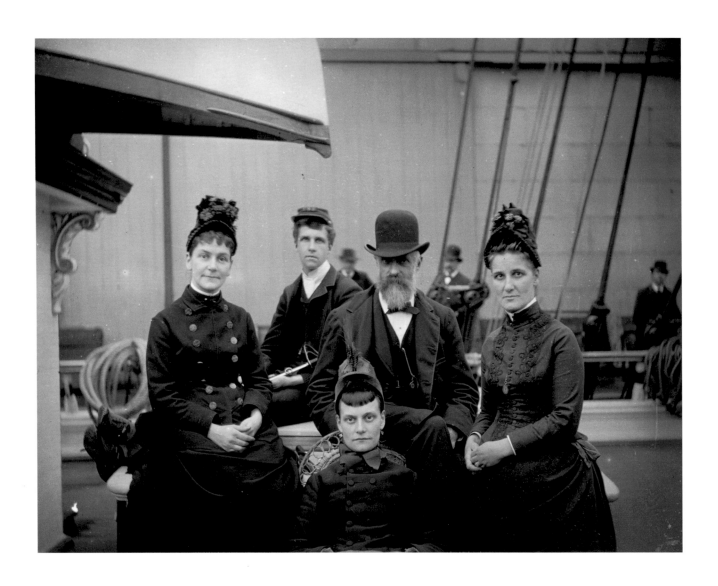

35. *Captain Charles A. Johnson of the Bark*
Amy Turner *and Family, circa 1882*

Unidentified photographer
Gelatin-silver print
Gift of Charles M. Wright, 1935

36. *St. Malo: Le gout roulant, circa 1880*

Unidentified photographer
Albumen print
Gift of the Bostonian Society, 1957

A contemporary newspaper account is pasted next to these photographs in an album of French coastal views: "One of the curiosities of the place, but quite a modern affair is the rolling bridge, which runs between St. Malo and St. Servan. Rails have been laid upon the ground, which are visible at low water, and over them roll the wheels of the great iron skeleton which supports the platform of the bridge."

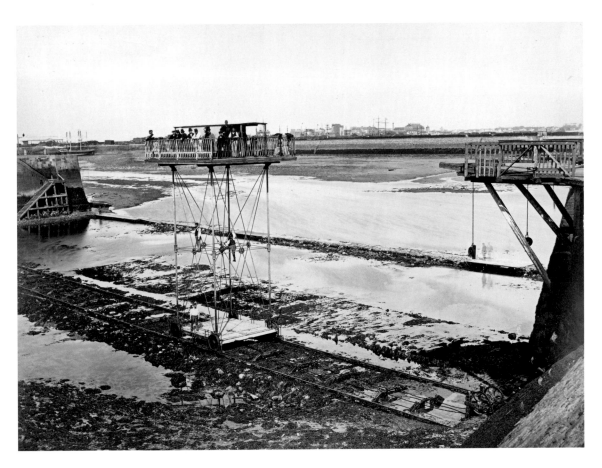

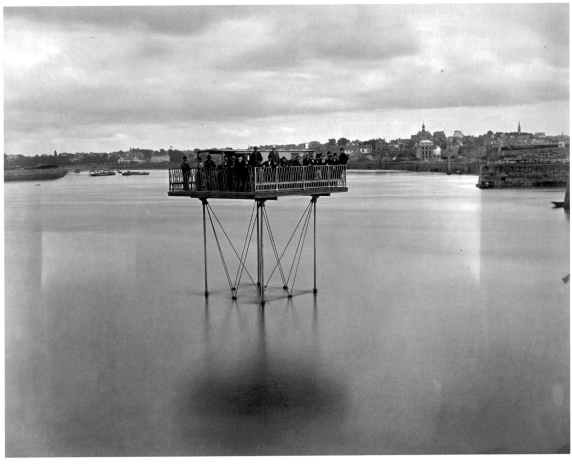

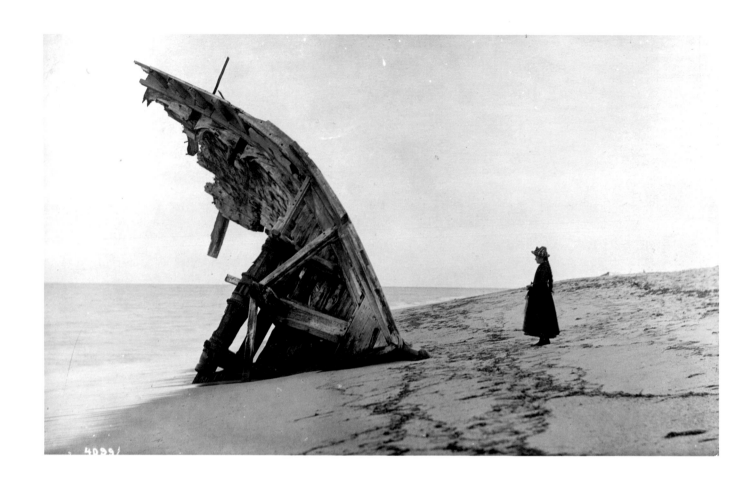

37. *Reflecting upon a Wreck at 'Sconset, Nantucket,*
Massachusetts, circa 1885

Baldwin Coolidge
Gelatin-silver print
Gift of the Society for the Preservation of New England Antiquities

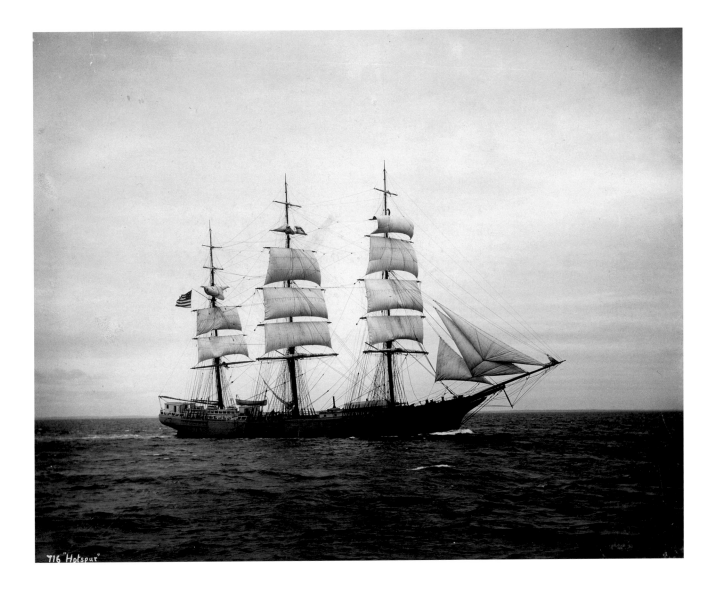

716 "Hotspur"

38. *Ship* Hotspur *of New Bedford, 1885*

Nathaniel Livermore Stebbins
Collodion printing-out paper
J. R. Neal Collection

The ship *Hotspur* was built at Bath, Maine, in 1885. Photographed on her maiden
voyage to Melbourne, Australia, the down-easter carried seven thousand yards of
canvas from main course to skysail. The sailor on the foremast yard is setting the
top-royal sail on the departure from Boston Harbor.

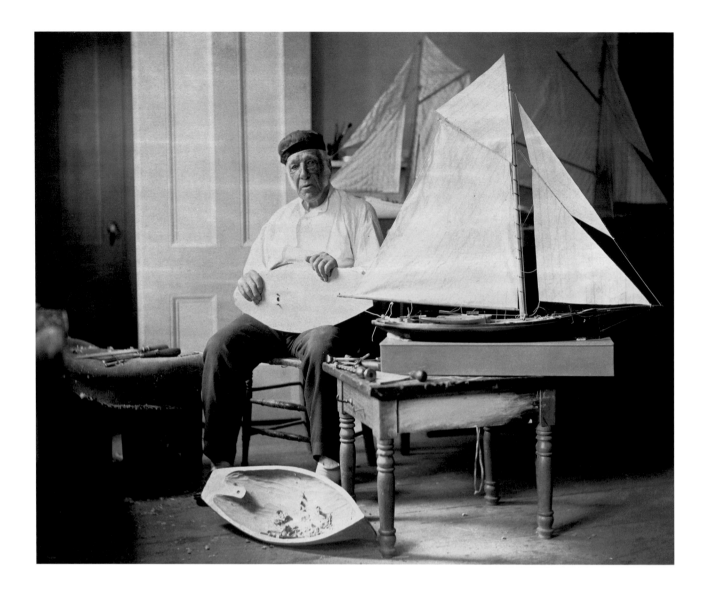

39. *Captain Robert Bennet Forbes, circa 1885*

Unidentified photographer
Albumen print
Gift of Mrs. Robert F. Herrick, 1940

The consummate mariner, Robert Bennet Forbes (1804–89), began his career at age thirteen on a voyage to China. For more than twenty years, he represented American business interests in China. Forbes was a part owner of sixty-eight vessels, including the first river steamer in China. He was an inventor, yachtsman, prolific writer, and avid supporter of sailors' relief organizations. Late in life, he took up model shipbuilding, and three of his creations are in the museum's collections.

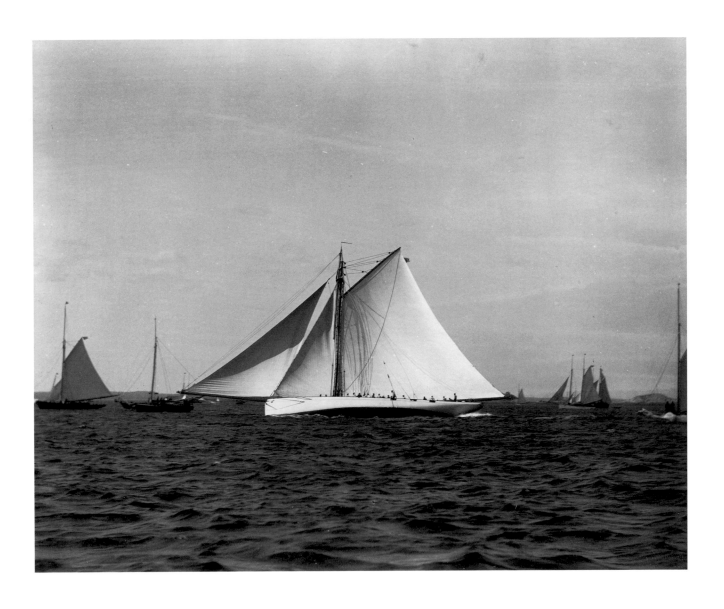

40. Puritan *at the Finish of the Eastern Yacht Club Race, 29 June 1886*

David Mason Little
Albumen print
Gift of Selina F. Little

As a pioneer of instantaneous dry-plate photography, David Little turned his camera on subjects that had been previously unrecordable with earlier and more primitive processes. He frequently photographed from the deck of his father's yacht *Brenda*. On at least one occasion, Little set his camera up directly in the surf to photograph an atmospheric seascape. The camera, slides, plates, and photographer were wrapped in gossamer waterproof cloth.

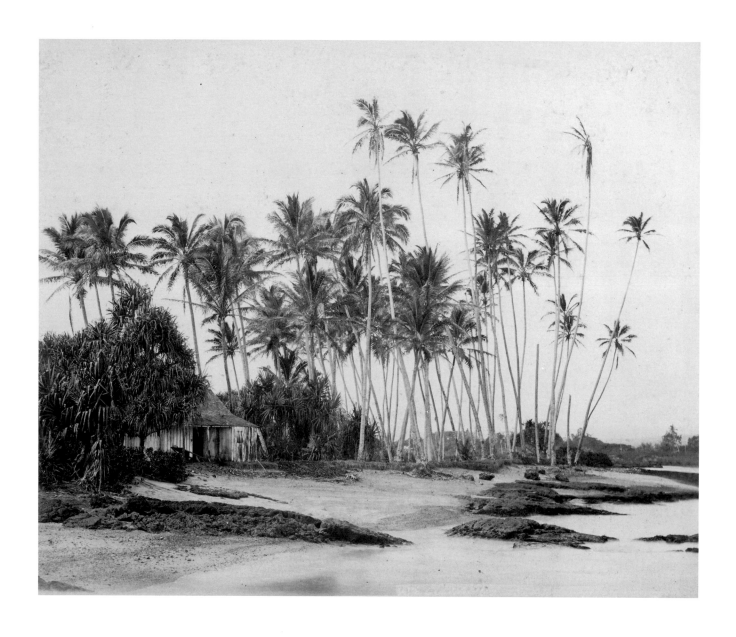

41. *Beach in Hawaii, 1880–90*

Unidentified photographer
Albumen print
Edward S. Clark Collection, 1952

Escape from the restraints of civilization for the easy life in a tropical paradise is not a recent fantasy. Maritime lore, literature, and even history from at least the early eighteenth century include stories of sailors who jump ship to form utopian communities on idyllic islands. Captain William Bligh felt that the mutiny on board H.M.S. *Bounty* was due to the "handsome, mild and cheerful women of Tahiti." The mutineers desired to escape the Royal Navy for a life "where they need not labour."

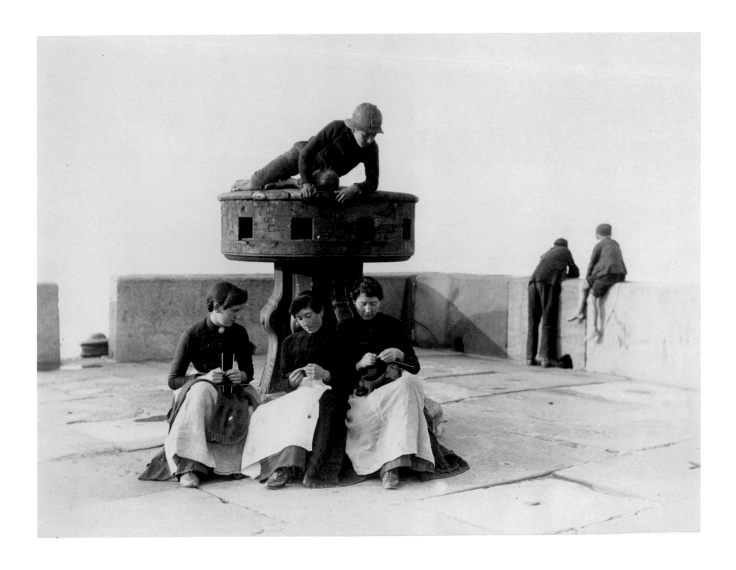

42. *Women and Children of the Fishing Port of Whitby, England, circa 1890*

Frank Meadow Sutcliffe
Albumen print
Gift of the Concord Free Public Library, 1949

As an art photographer, Sutcliffe was primarily interested in the composition, lighting, and tonal qualities of his finished work. Yet, he accomplished this without models or costumes, but by using working residents from his hometown of Whitby. The woman at the center is making lace, while the other two are knitting the thick fisherman's sweaters so common in the region. These sweaters were said to each have unique patterns, and that they were used on more than one occasion to identify a fisherman's body after an unfortunate incident at sea.

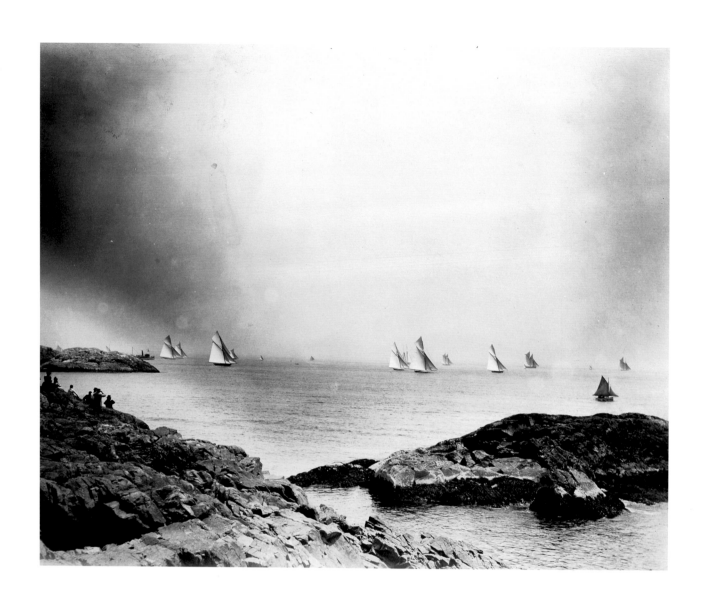

43. *Yacht Race off Marblehead, 16 July 1891*

Frank Cousins Art Company
Gelatin-silver print
Museum purchase

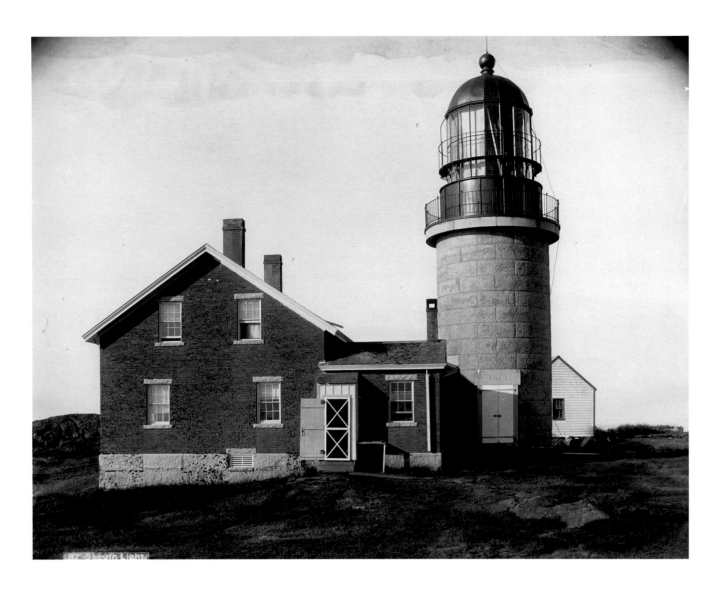

44. *Seguin Light, Maine, 1886–1900*

Henry Greenwood Peabody
Gelatin developing-out paper
Museum purchase, 1942

Working for the Boston and Maine Railroad Company, Henry Peabody traveled the New England coast in a train car especially fitted out for him to process his photographs of coastal views and yachts. Peabody's perspective focuses only on the relatively small lighthouse, and not on its commanding placement atop a steep bluff.

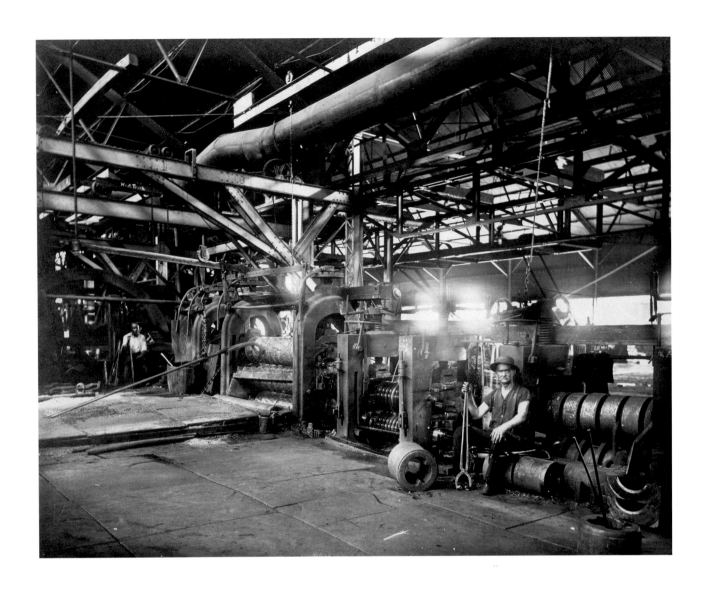

45. *Armor Rolling Machinery at the Tredegar Iron Works, Richmond, Virginia, circa 1893*

Unidentified photographer
Gelatin developing-out paper

This photograph comes from an album compiled to commemorate the Civil War. While most of the memorabilia is from participants in the war, this particular image features the technology used to build the new ironclad ships. A notation accompanying the photograph reads:

"The original rolling machinery at the Tredegar Iron Works, Richmond, Va. which rolled the armor plates (made from railroad iron) for the confederate ironclad *Merrimack* or *Virginia*. The man sitting in the foreground is the identical one that did the work."

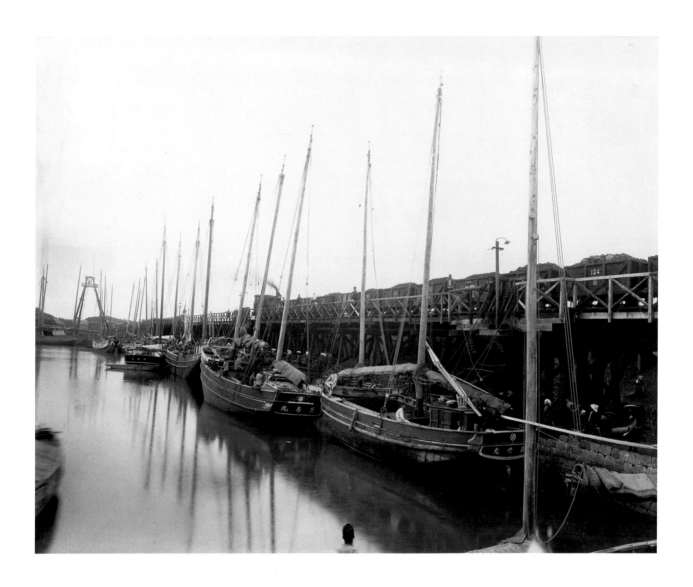

46. *Loading Coastal Colliers, Japan, 1895*

Mitoma
Gelatin-silver print

The Japanese photographer Mitoma documented the process of loading coal onto coastwise barges. The photograph was first exhibited at the Fourth National Industrial Exposition in Kyoto in 1895. From right to left, boat names are *Shotoku Maru, Tamayoshi Maru,* and *Kanun Maru.*

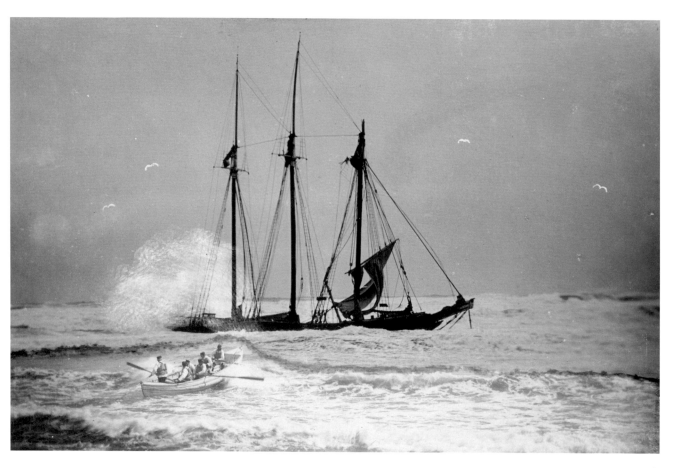

47. *Lifesavers to the Rescue of the Schooner* Jennie Carter *in 1894, Salisbury Beach, Massachusetts*

Selwyn C. Reed
A. and B. gelatin-silver prints
C. color postcard

On the morning of 13 April 1894 following a stormy night, members of the Plum Island lifesaving station discovered a three-masted schooner stranded on the sand three and a half miles north of them. Going aboard, they salvaged a sextant, compass, and aneroid barometer for the owners. For several days, they searched for bodies, finding three.

By the time the local commercial photographer Selwyn Reed recorded the wreck, it was already abandoned. Undaunted, he decided to dismiss the true historical moment and enhance his image in the darkroom with the additional drama of a lifesaving crew at work (A). He inserted the same scene in the foreground when he photographed the wreck again at a later date (B). The immediacy of imminent threat to life augments the marketability of the final product, a postcard sold to beach-going tourists (C).

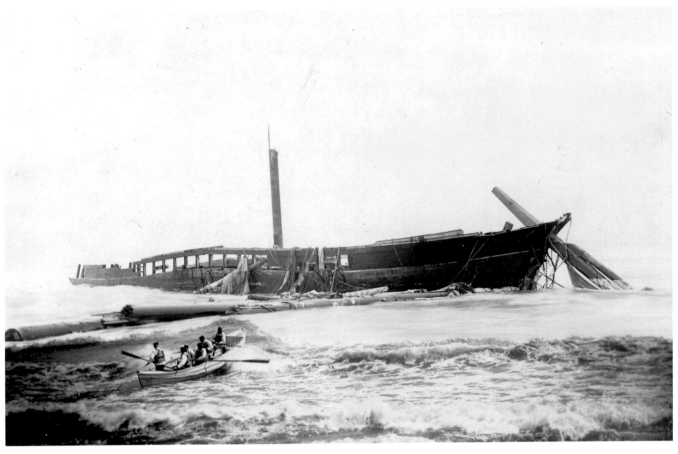

B.

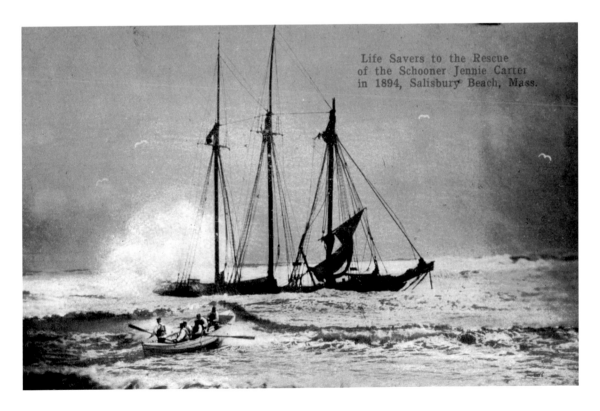

Life Savers to the Rescue
of the Schooner Jennie Carter
in 1894, Salisbury Beach, Mass.

C.

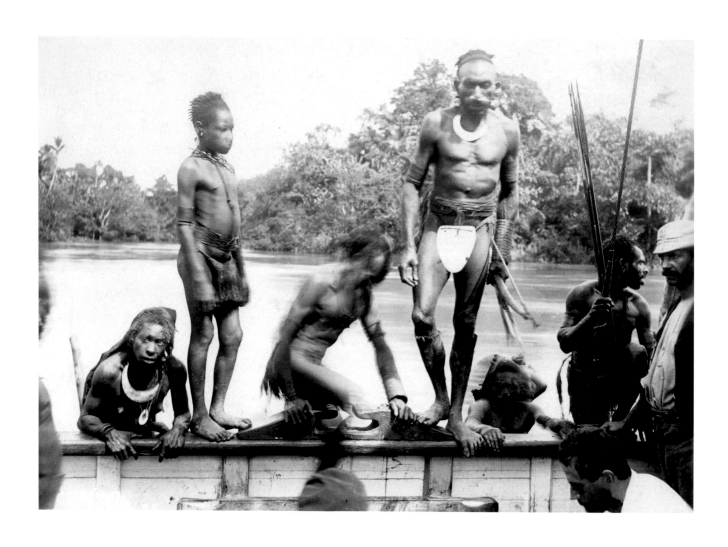

48. *Come Aboard, Sir!, 1890–1900*

Unidentified photographer
Albumen print
Gift of Mrs. Sumner Pingree, 1943

By the end of the nineteenth century, mariners could encounter nonacculturated Pacific islanders in only a few remote regions. This shipboard visit took place in lowland New Guinea and appears in one of a set of albums of Pacific island scenes acquired by Dr. Charles Goddard Weld.

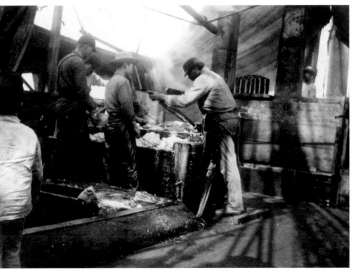

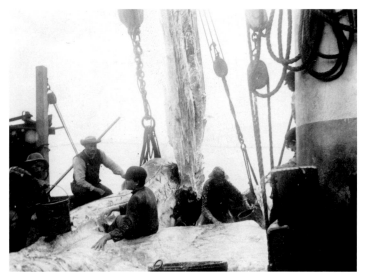

A.

C.

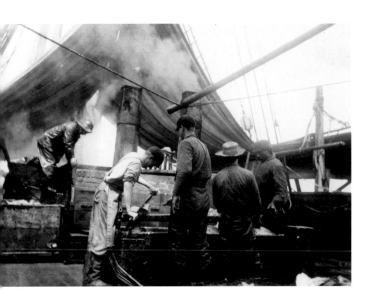

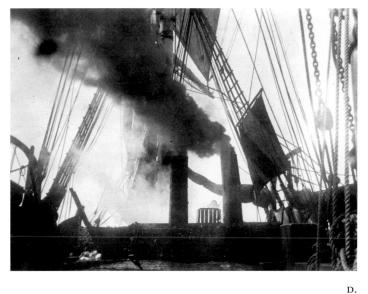

B.

D.

49. *Scenes on Board the Whaler* Charles W. Morgan, *1890–1906*

A. and B. Slicing the blubber; C. Bailing out the case; D. Boiling out
Mrs. James A. M. Earle
Gelatin-silver prints
Gift of Henry C. Hallowell, 1934

These impromptu snapshots, taken by the wife of Captain Earle, document routine deck activities of the offshore whaling industry. Exactly where these photographs were taken is unknown since the ship sought whales in both the Pacific and Atlantic Oceans under Earle's command. Women who accompanied their husbands often wrote about their experiences aboard whalers, but few actually photographed them.

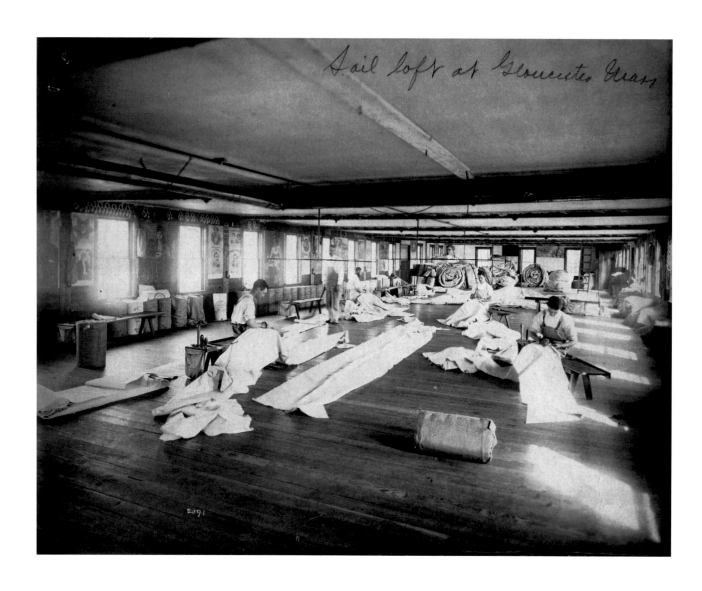

50. *Sail Loft at Gloucester, Massachusetts, 1890–1900*

Unidentified photographer
Cyanotype
Gift of the Smithsonian Institution, 1956

51. *View from the Bowsprit of U.S.S.* Portsmouth, *1880–1900*

Unidentified photographer
Acetate film negative
Gift of Mrs. Clarkson A. Cranmer, 1955

The sailor who created this photographic montage was precariously balanced on the bowsprit. Three different camera angles show the full-rigged ship from the perspective of one handling the sails. Unlike the more formal broadside presentation, this perspective places the viewer in the shoes of the working sailor.

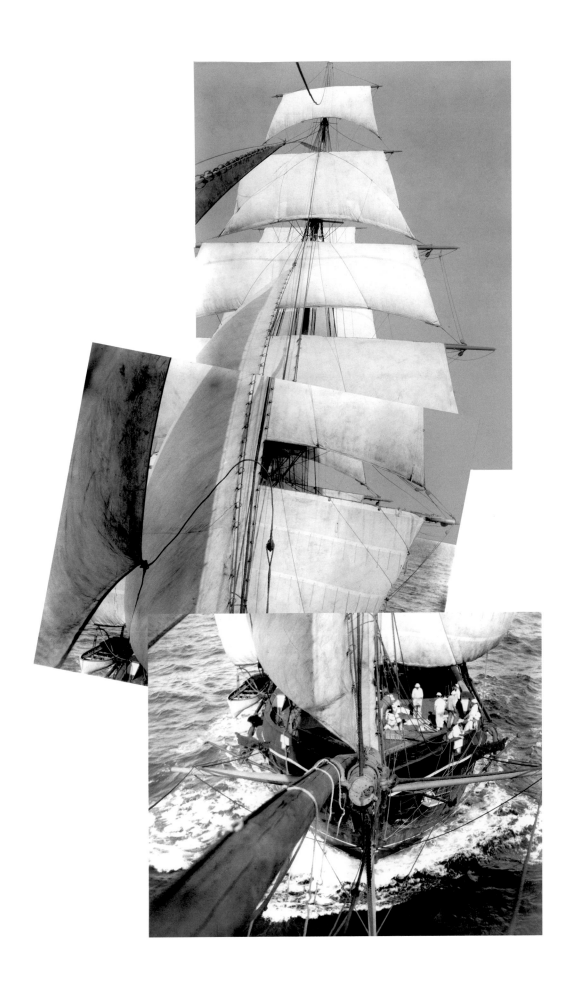

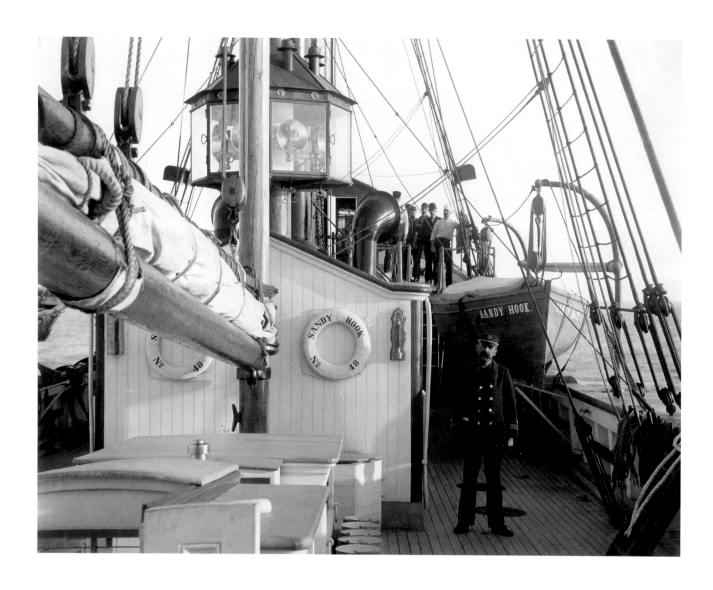

52. *Deck of the Sandy Hook Lightship, circa 1894*

Henry Greenwood Peabody
Matte collodion printing-out paper with platinum toning
Museum purchase, 1942

Early in his career, Henry Peabody specialized in photographs of racing yachts and other marine scenes. This image of the master and deck of light vessel 48 shows the ship that Peabody used as a platform for his large-format camera.

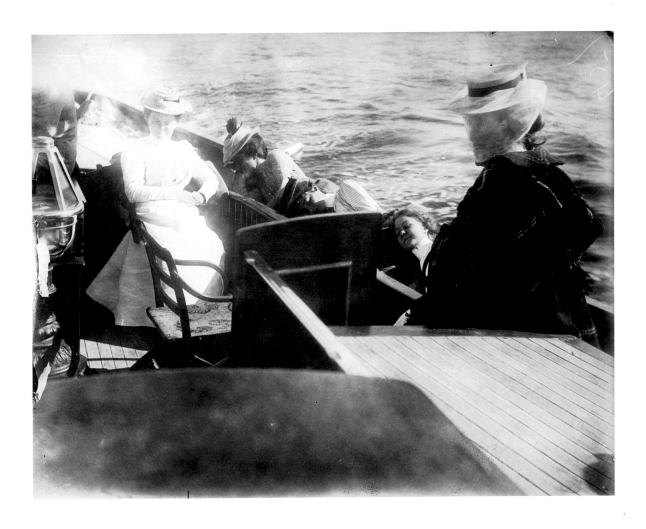

53. *Lounging on the Afterdeck, 1895–1900*

Unidentified photographer
Gelatin-silver print

The stiff breeze and gleaming reflections of bright sunlight on water are clearly evident in this image of five unidentified members of a yachting party relaxing on the port bench. These effects of nature were captured by an amateur photographer employing one of the easy-to-use box cameras that had become popular by 1890. The photographer, whose vacant chair appears in the center, is undoubtedly a member of the party as well.

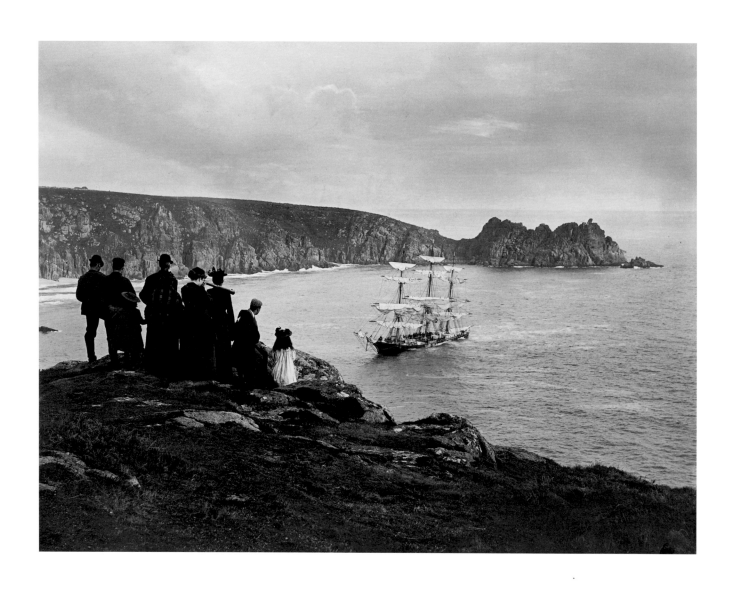

54. *Wreck of the Ship* Granite State *of Portsmouth, New Hampshire, at Land's End, 1895*

Gibson and Sons
Gelatin printing-out paper
F. B. C. Bradlee Collection

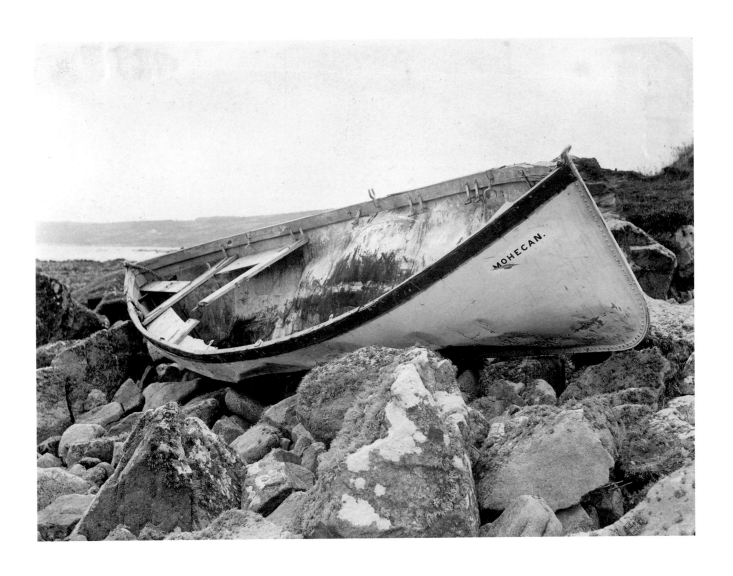

55. *Lifeboat from S.S.* Mohegan *Wrecked 14 October 1898*

Unidentified photographer
Albumen print
F. B. C. Bradlee Collection

On a voyage from London toward New York, the liner *Mohegan* struck a ledge head-on near the Lizard, off Cornwall. She sank in fifteen minutes after only two of her lifeboats had cleared. One hundred and six people, including the captain and the officers, were lost.

This serene image of the lifeboat ashore is in contrast with the violent action that brought it there.

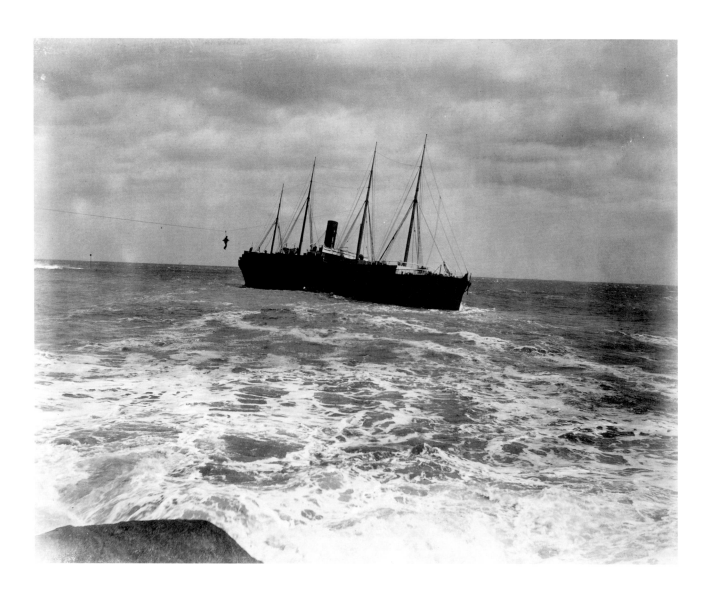

56. *S.S.* Norseman *Aground on Tom Moore's Ledge, off Marblehead Neck, 29 March 1899*

Unidentified photographer
Gelatin developing-out paper
Gift of Lawrence W. Jenkins, 1916

Inbound to Boston from Liverpool, the steamer *Norseman* ran aground in a thick fog early in the morning of 29 March 1899. At the time of the photograph, the ship was in a precarious situation with a large hole in her bottom and the hold full of water. The volunteer lifesaving crew of Marblehead was running a breeches buoy operation, but with 102 people aboard the ship at two hundred yards from shore, the endeavor would take the entire day. A newsman reported the scene thus: "The breeches buoy slides on the rope by a pulley, and running from this pulley either way are ropes by which the speed can be controlled by those on shore or on board the ship. During the forenoon there were some exciting trips as the tide arose. Some of the men were plunged into the surf, but a wetting wasn't like being a drowned man who is generally a long time wet." All aboard were eventually rescued, and the ship was refloated.

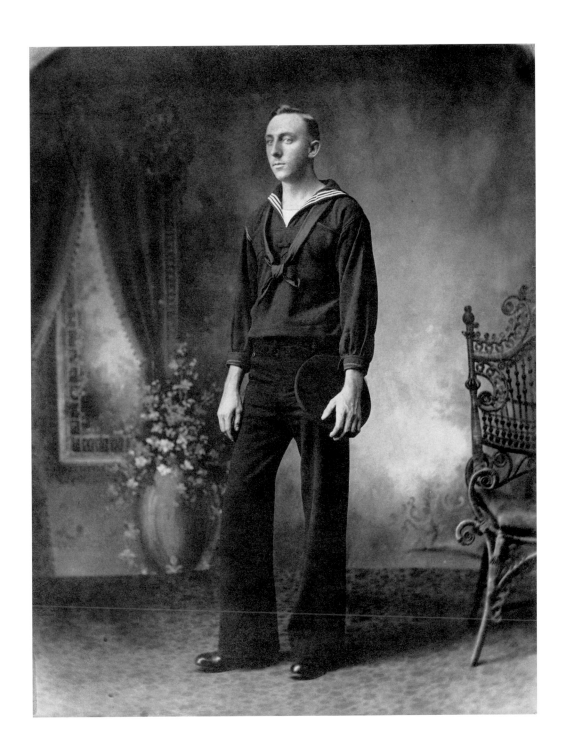

57. *Studio Portrait of an Unidentified Sailor in Uniform,*
circa 1898

Unidentified photographer
Gelatin-silver print

Although the sailor, photographer, and location of the studio are all unknown,
this image is nonetheless an evocative portrayal of an ordinary young seaman
preparing to depart from home.

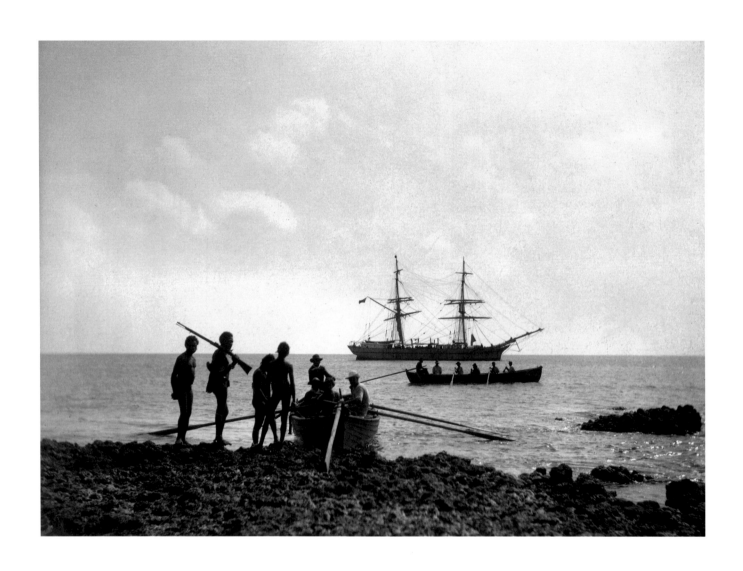

58. *Recruiting Labor, Malicolo (Malekula), New Hebrides, circa 1900*

Unidentified photographer
Albumen print
Gift of Mrs. Sumner Pingree, 1943

In the later nineteenth century, it was common for sailors to cruise among remote Pacific islands in search of cheap labor to assist with resource harvesting, marine salvage, and general shipboard labor.

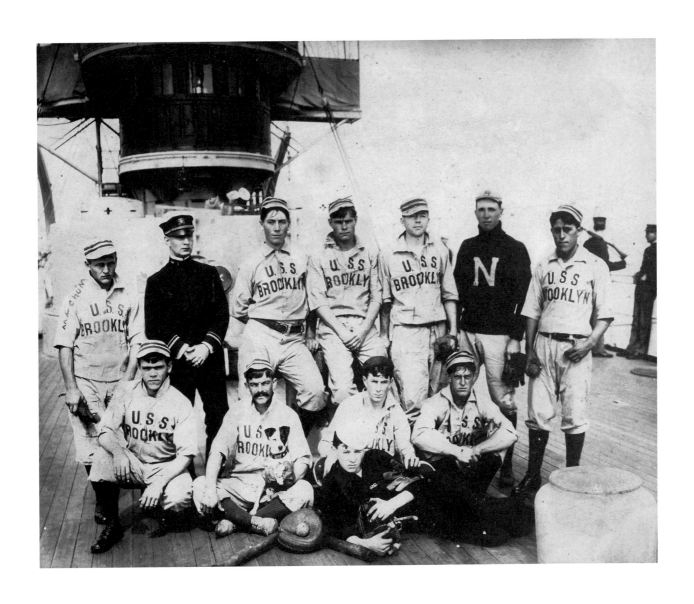

59. *Baseball Team of U.S.S.* Brooklyn, *1896–1910*

Unidentified photographer
Albumen print

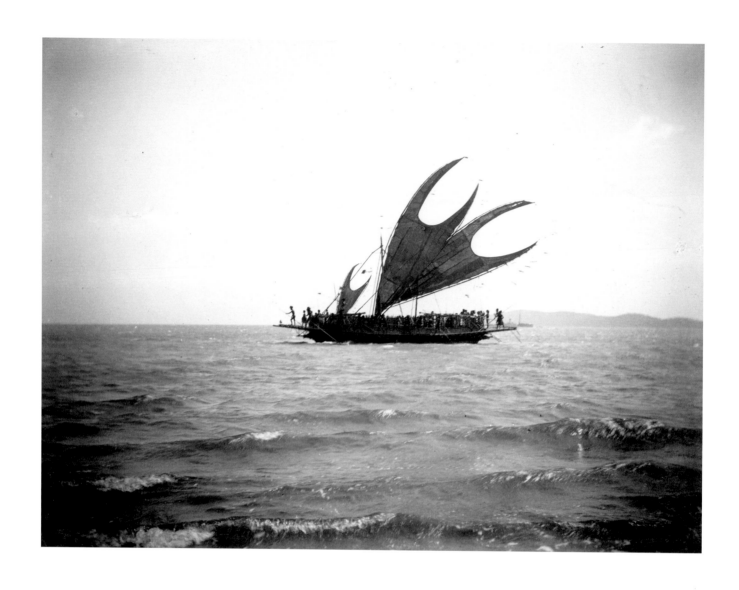

60. *Lakatoi, near Port Moresby, New Guinea, circa 1900*

Unidentified photographer
Albumen print
Gift of Mrs. Sumner Pingree, 1943

Large double-hull canoes called lakatoi were used for annual trading voyages from the Gulf of Papua to as far as the Louisiade Archipelago, four hundred miles to the east. In the 1870s, as many as twenty canoes and six hundred men made the voyage. By 1903, only four canoes sailed out of the Port Moresby area. The distinctive crab-claw sails made the canoes extremely efficient.

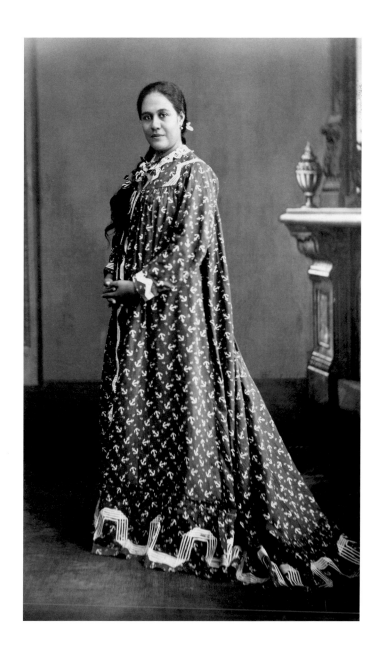

61. *Manihinihi (Chickie), Papeete, Tahiti, 1899–1900*

Attributed to Charles Spitz
Matte collodion printing-out paper
Museum purchase, 1977

The Tahitian woman poses for the photographer in clothing that embodies the influence of European colonization. The anchors signify the means by which Europeans came to dominate her native island. The loose-fitting imported cotton garment, based on a fashionable Western housedress, has been adapted for wear in a hot tropical climate. This photograph is part of an album compiled by zoologist Alexander Agassiz, leader of the South Sea expedition to the Marquesas and Society Islands.

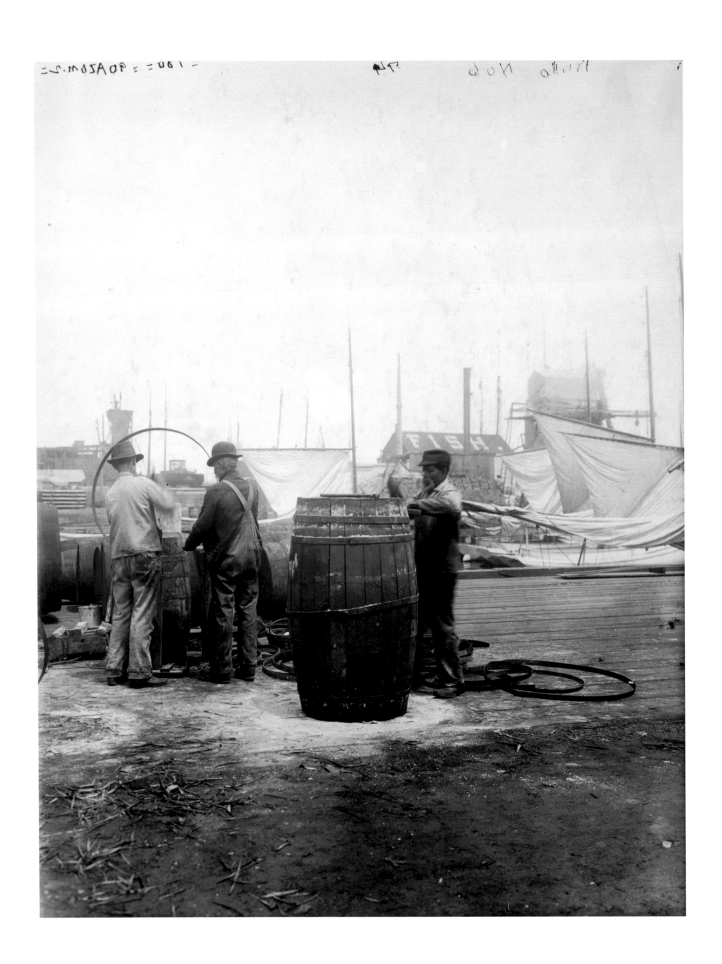

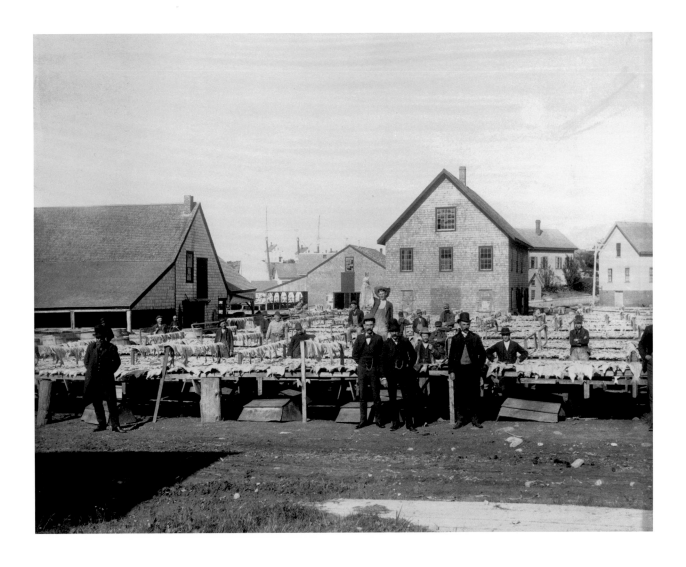

63. *George Dennis's Fish Curing Establishment, East Gloucester, circa 1900*

Unidentified photographer
Albumen print
Gift of Lawrence W. Jenkins, 1936

During the last three decades of the nineteenth century, George Dennis's company was one of many fish wholesalers in Gloucester, Massachusetts. This promotional photograph presents Dennis's thriving operation.

62. *Coopers at Work, New Bedford, 1890–1910*

Unidentified photographer
Gelatin developing-out paper
Museum purchase, 1931

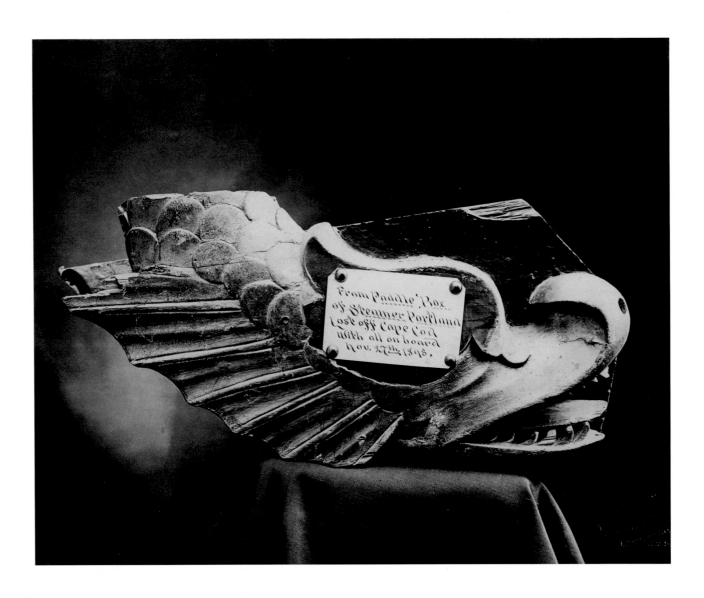

64. *Artifact from the Steamer* Portland, *circa 1900*

George H. Wilbur
Gelatin developing-out paper
F. B. C. Bradlee Collection

In opposition to the traditional maritime photograph, which is almost by definition taken amid an "authentic" outdoor setting, this image was taken in a studio, an artifact presented as a still life. Snatched from its natural context and placed on a pedestal, the fragment of the ill-fated steamer *Portland* has already been transformed from a historical relic into a sculptural icon. Here, the photograph itself becomes a museum object, transformed from document into art work.

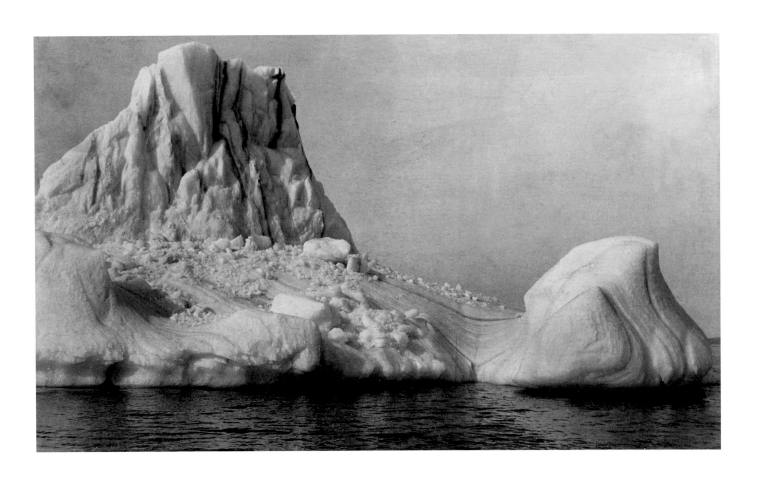

65. *Iceberg*

Unidentified photographer
Albumen print
Gift of Beverly and Joe Sturgeon, 1992

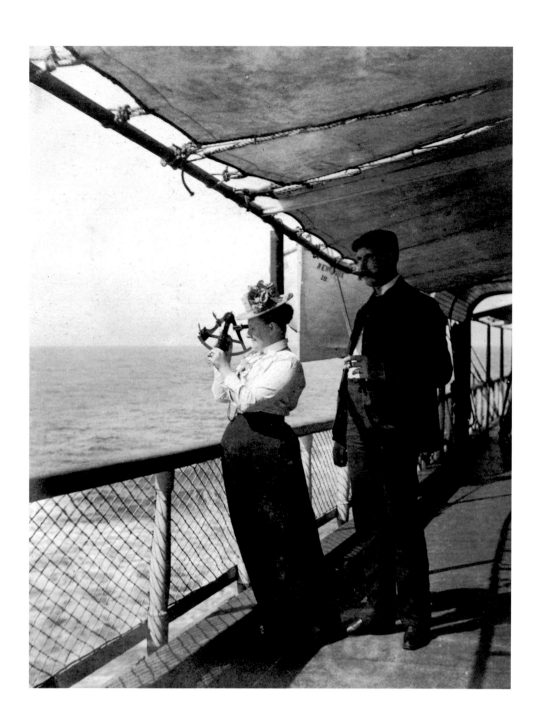

66. *A Lesson in Navigation, circa 1900*

Unidentified photographer
Gelatin developing-out paper
Gift of Robert McRoberts, 1938

This unassuming snapshot taken on the deck of a passenger steamer is from a personal photograph album probably compiled by Captain W. J. Connell or his wife. The album contains many informal photographs that chronicle a sequence of personal memories for the Connells, taken at home in San Francisco and aboard several merchant ships, including the Pacific Mail steamship *City of Sydney* from New York.

67. The Daily "Run, Jump and Plunge" at Cushing Island, Maine, circa 1898

Unidentified photographer
Gelatin developing-out paper
Museum purchase, 1947

By the end of the nineteenth century, the Maine coast was becoming a mecca for wealthy city dwellers and middle-class tourists. Seaside resorts, such as the one built by Lemuel Cushing on Cushing Island in Casco Bay, offered summer visitors healthy, organized outdoor experiences designed for the betterment of body and soul.

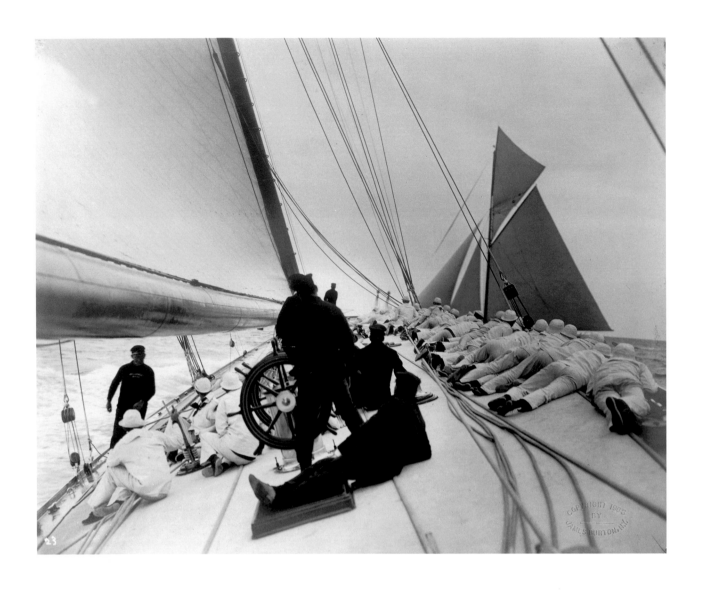

68. *On Board* Reliance, *1903*

James Burton
Gelatin developing-out paper
Gift of the Bostonian Society, 1957

William Rockefeller and Cornelius Vanderbilt commissioned Nathanael Herreshoff to design *Reliance* to defend the America's Cup from Sir Thomas Lipton's *Shamrock III. Reliance* had a length at the waterline of ninety feet and an immense length of 144 feet overall.

Reliance is pointed directly at the lightship, the masts of which can be seen at center. Both yachts are trying to round the mark first for the next leg of the race.

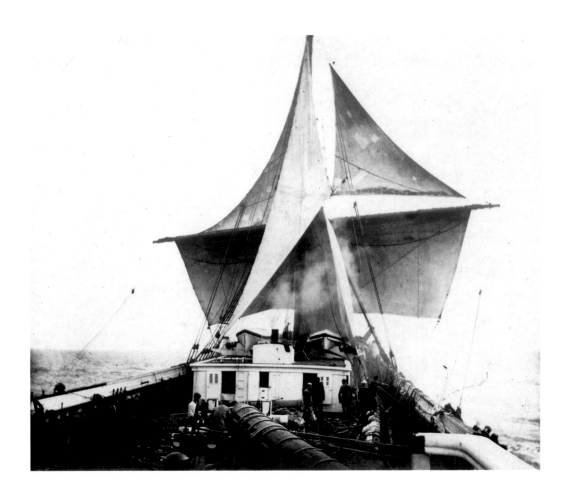

69. *The Ship* A. G. Ropes *Dismasted in a Typhoon, July 1905*

Unidentified photographer
Gelatin-silver print
Edward S. Clark Collection, 1956

Bound across the Pacific for Kobe, Japan, a typhoon swept away most of the ship's masts and rigging. Still in mid-ocean, the crew begins the onerous task of clearing the deck and constructing a jury rig from what remains. Following her arrival, *A. G. Ropes* was converted to a barge, too far damaged to restore her rig.

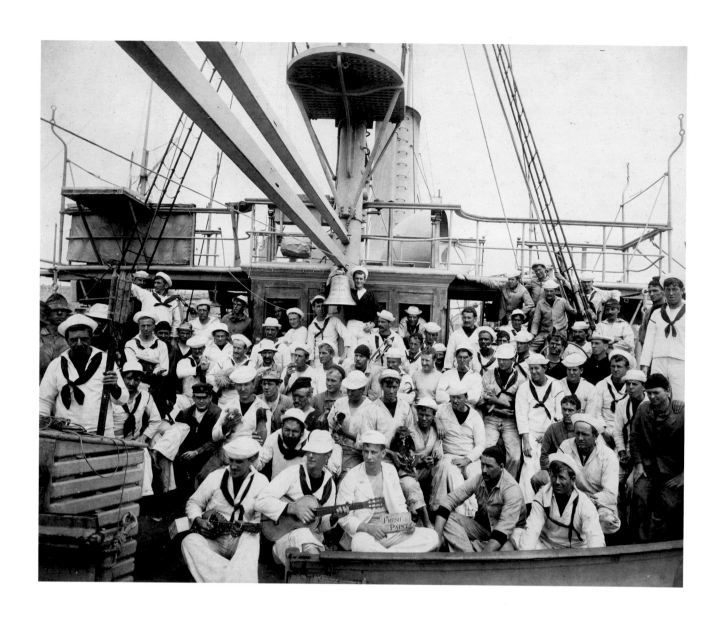

70. *U.S.S.* Isla de Cuba, *1904–7*

Lafayette V. Newell and Company
Gelatin printing-out paper
Museum purchase, 1943

This photograph is considerably less formal than the standard portrait of a ship's crew.
These sailors are pictured with an odd assortment of items of shipboard life: musical
instruments, fireworks, various pets, a grappling hook, food, and tobacco products.

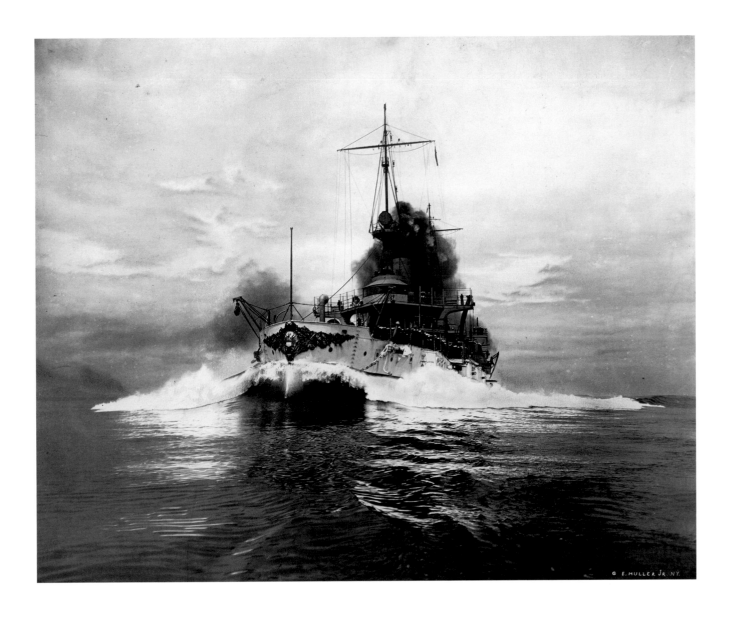

71. *U.S.S.* Connecticut *on Her Trial Run, 1906*

Enrique Muller Jr.
Gelatin developing-out paper
Gift of Mrs. David Mason Little, 1925

To capture the power of the newest addition to America's battleship fleet, the photographer placed himself in close proximity to the oncoming dreadnought, which was steaming along at over eighteen knots. Seconds after the photograph was taken, Muller's boat was swamped.

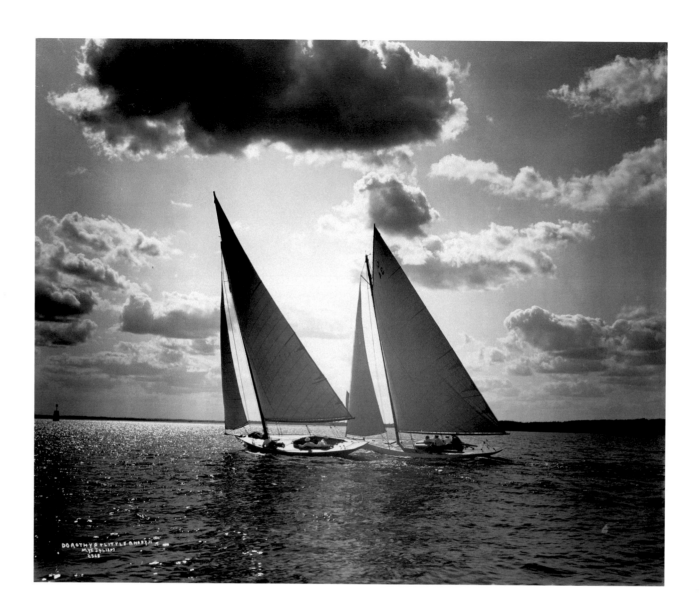

72. Dorothy Q *and* Little Rhody II, *13 July 1907*

Willard Bramwell Jackson
Gelatin developing-out paper
Gift of Russell W. Knight

Willard Jackson is a little-recognized master of marine photography. Jackson created large-format glass-plate negatives of his subjects. Many of his resulting photographs are contact prints, a process that does not lend itself to significant darkroom manipulation but highlights his consummate skill with a camera.

73. *Figurehead of Ship* Sam Skolfield II *over the Sailors Haven at Water Street, Charlestown, Massachusetts, circa 1910*

Unidentified photographer
Gelatin developing-out paper
B. B. Crowninshield estate, 1950

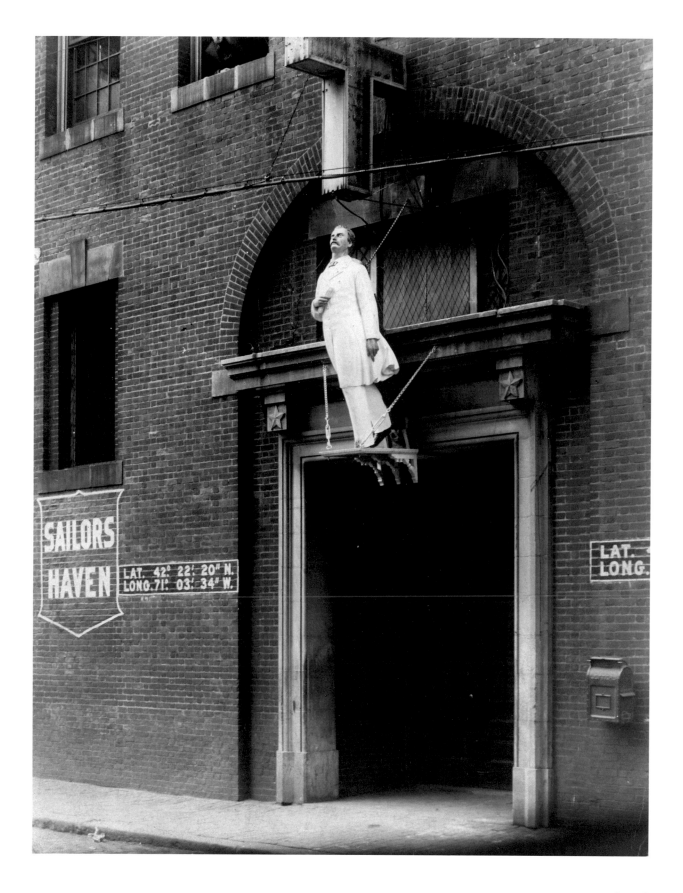

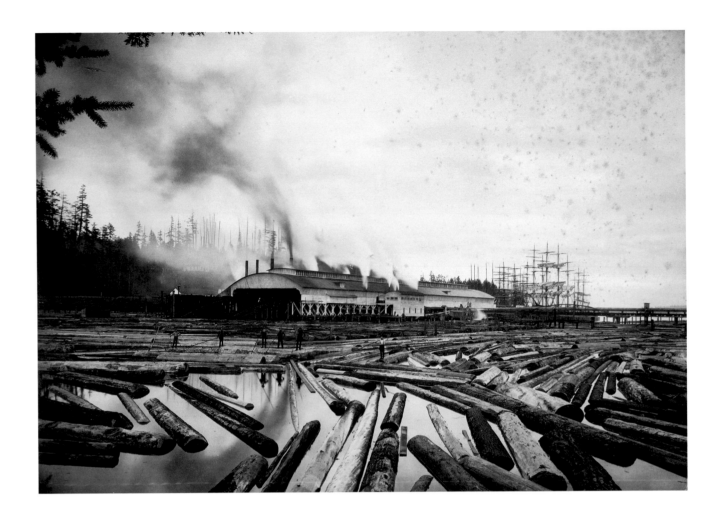

74. *Lumber Mill, Port Blakely, Washington, circa 1900*

Wilhelm Hester
Albumen print
Museum purchase, 1952

Wilhelm Hester made and sold photographs of the ships and sailors along the waterfronts in Tacoma, Seattle, and Port Blakely. The great sawmills at Port Blakely drew many sailing ships to Puget Sound for lumber, providing Hester with a ready market for his photographs. Many times, he had to photograph in the challenging weather conditions of rain and fog, but he used them to his advantage in creating remarkable images. His compositions are primarily documentary; yet they also possess a particularly strong atmospheric quality.

Here, Hester has framed a narrative of Port Blakely's logging industry. The massive logs await processing in the lumber mill, eventually to be loaded onto the sailing ships in the background that are destined for distant ports.

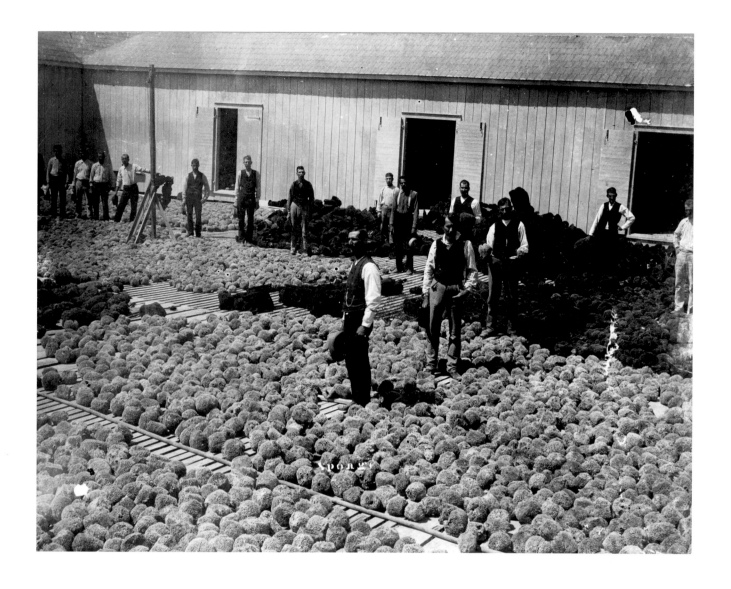

75. *Sponges, circa 1910*

Unidentified photographer
Gelatin-silver print
Gift of Mrs. Charles A. Benjamin, 1916

The sponges are being dried and then sorted by type and quality for sale at auction. For many years, the sponge fishery was one of the largest industries in Florida.

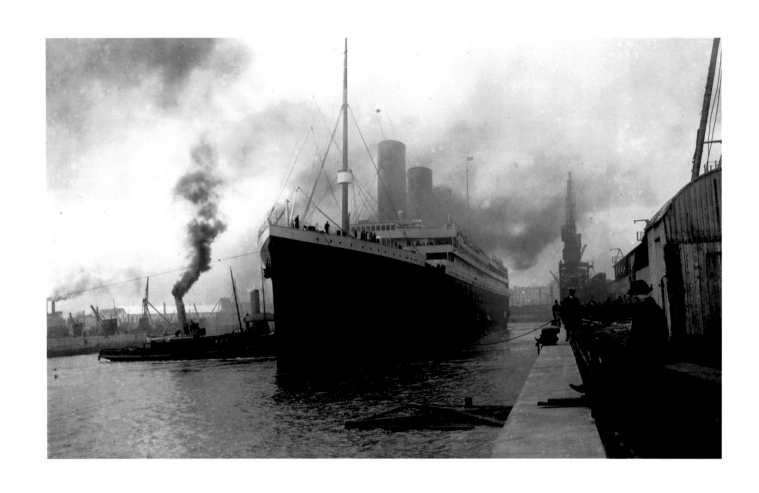

76. *R.M.S.* Titanic *at Southampton, England, 10 April 1912:*
Letting Go the Last Line

Unidentified photographer
Gelatin-silver print
Eugene Smith Collection

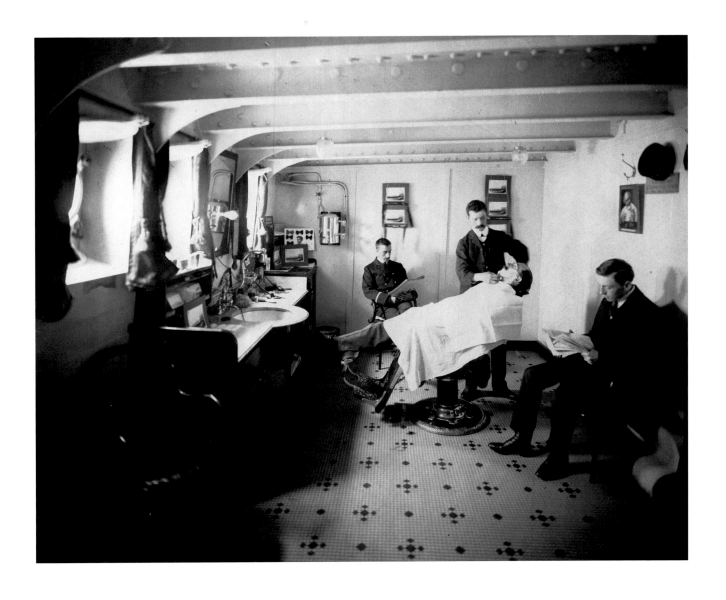

77. *Barber Shop on Board* Empress of Ireland, *1906–12*

Unidentified photographer
Gelatin printing-out paper
F. B. C. Bradlee Collection, 1928

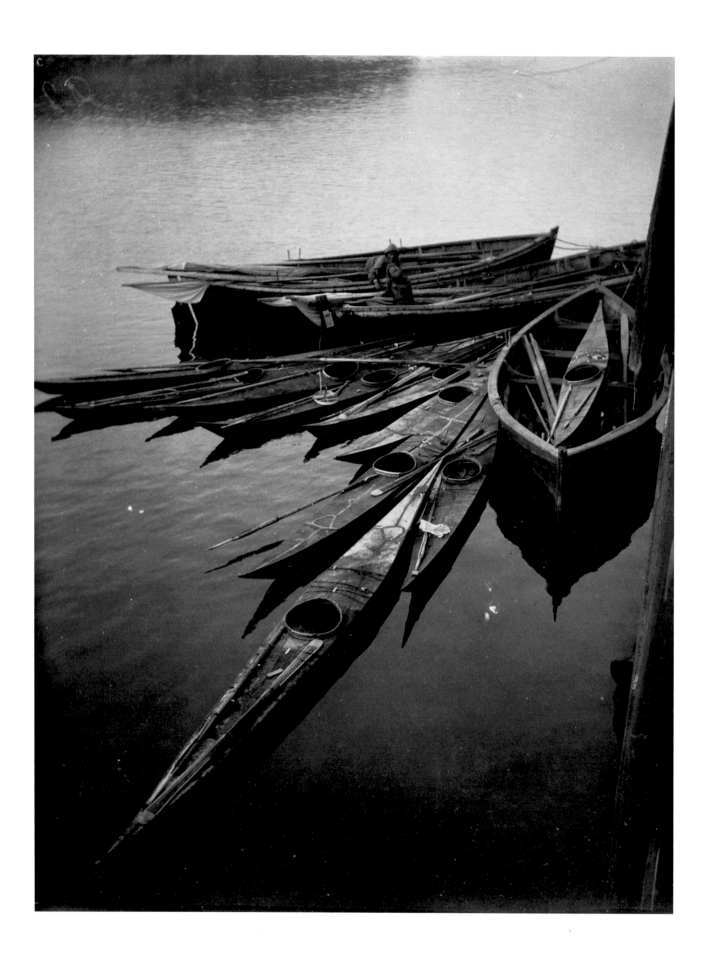

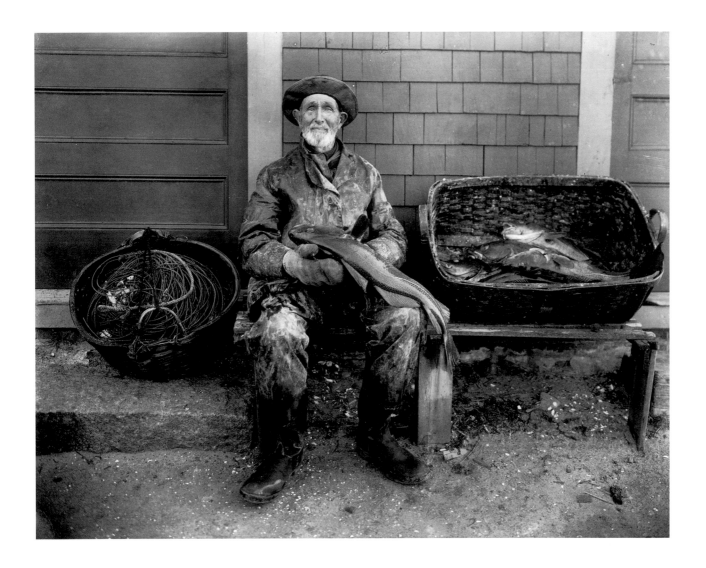

79. *Theophilus Brackett circa 1916*

Frederick S. Rankins
Gelatin-silver print

Commercial photographer Frederick Rankins of Lynn, Massachusetts, captured an image
of working-class New England in the dozen portraits he entitled "The Old Swampscott
Fishermen Series." When Theophilus Brackett (1839–1916) sat for his portrait, he was
seventy-seven years old.

78. *Inuit Sealskin Kayaks, Greenland, circa 1916*

Unidentified photographer
Gelatin printing-out paper
Gift of Robert Evans, 1978

A photographer accompanying a Yale expedition to Newfoundland and Greenland highlighted
the narrow elegance of Inuit kayaks juxtaposed with the wider and larger ship's boat.

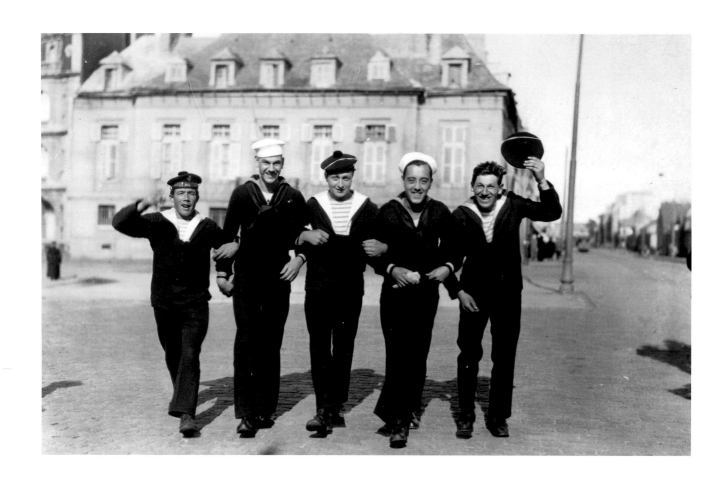

80. *Allies Again! American and French Sailors in Cherbourg, circa 1918*

Unidentified photographer
Gelatin-silver print
Gift of Alfred K. Schroeder, 1981

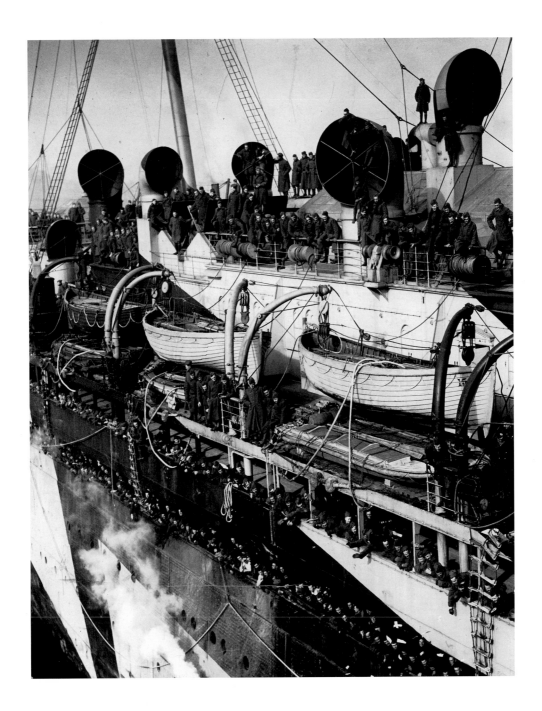

81. *First American Troops Arriving from Overseas on 2 December 1918*

Unidentified photographer
Gelatin-silver print
Gift of Francis Lee Higginson Jr., 1972

During the First World War, the Cunard liner *Mauretania* carried nearly seventy thousand troops. Those pictured here had an unusual war experience. The ship was headed toward Liverpool with fresh recruits when they received news of the armistice. Upon arrival, they qualified for a medal and within hours, *Mauretania* reembarked for New York. As the first soldiers to return from Europe, they were treated to a grand welcome by the city.

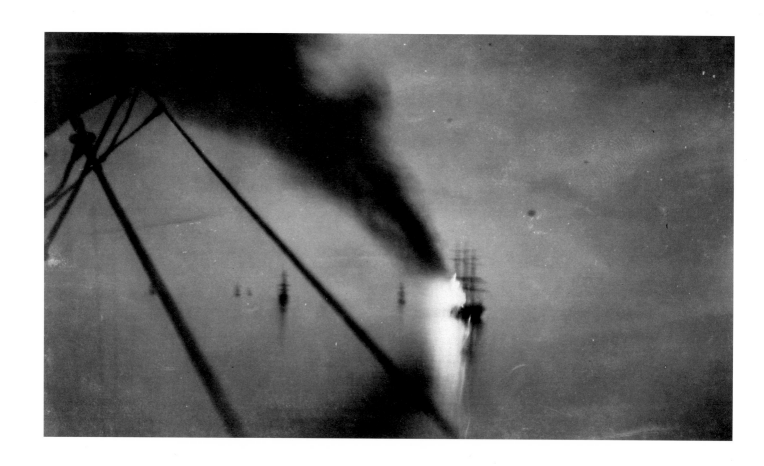

82. *The Ship* Charles E. Moody *on Fire, 20 June 1920*

Unidentified photographer
Gelatin-silver print
Gift of Axel F. Widustrom, 1959

One of the greatest fears of mariners is fire, which moves swiftly through aged wooden ships with tarred rigging and canvas sails. A sailor, fascinated by the conflagration, took this snapshot as *Charles E. Moody* burned at Bristol Bay, Alaska.

83. *Three Unidentified Yachtsmen, circa 1920*

Unidentified photographer
Albumen print
Gift of Col. George L. Smith, 1957

84. Launch of S.S. Antonia *at Barrow-on-Furness, England, 1921*

Unidentified photographer
Gelatin developing-out paper

Ship launchings are popular moments to memorialize in photographs. Unlike most launching scenes where the christening bottle is breaking or the ship is sliding down the ways, *Antonia* rests stationary in the water, waiting to be taken in tow by the steam tugs. Workers in rowboats are picking up the lumber dragged into the harbor during her launch.

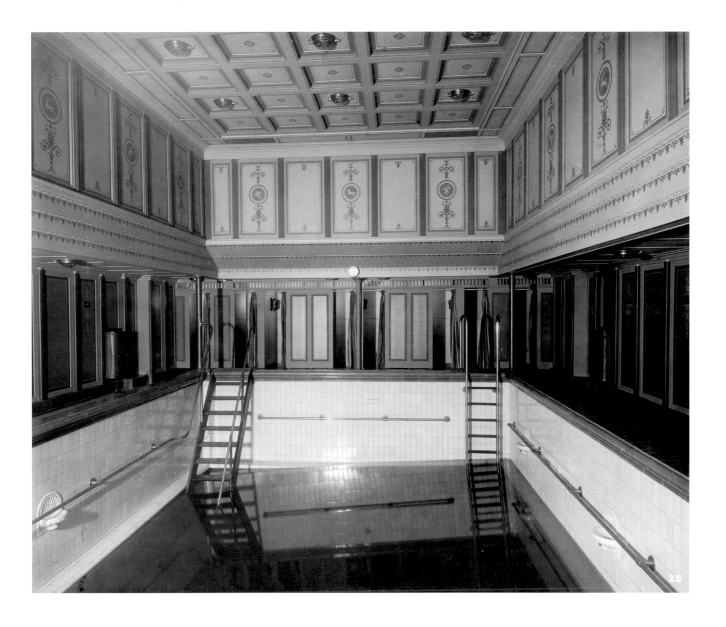

85. *First-Class Swimming Bath, S.S.* Empress of Australia, *circa 1922*

Bedford Lemere and Company
Gelatin-silver print
Gift of Canadian Pacific Railway, 1950

Using a large-format view camera with a bellows and a tripod, a photographer can manipulate
straight architectural lines receding into the distance to moderate the effects of scale and perspective.
Unfortunately, such manipulation cannot completely ameliorate the awkward appearance of angled
water resulting from a listing ship. This photograph was taken for the Canadian Pacific Steamship
Company when the liner was in port, where the swimming baths were always kept drained.

The handwritten inscription on the photograph reads:

Rather good picture, eh, what! Who is the youth holding up the rail? No in my acquaintance list. You see I only knew the Elite of the 1st cabin passengers.

86. *On Board S.S.* Lapland, *1915–25*

Unidentified photographer
Gelatin developing-out paper
Gift of Mrs. George Loring, 1987

The steamer *Lapland* carried 450 first-class passengers, 400 in second class, and 1,500 in third class or steerage. The unidentified passenger inscribed this photographic postcard with a tongue-in-cheek reference to situate himself within the rigid social hierarchy aboard the liner.

87. *Fo'c'sle Quarters on Board the Tug* Charles Clarke, *Galveston, Texas, 1920–30*

Paul Verkin Sr.
Nitrate film negative
Verkin Collection

Paul Verkin's photographs record various activities in the port of Galveston, Texas. He primarily shot the steamships and freighters that called there, but occasionally he photographed more mundane subjects like the cramped living quarters of a tugboat.

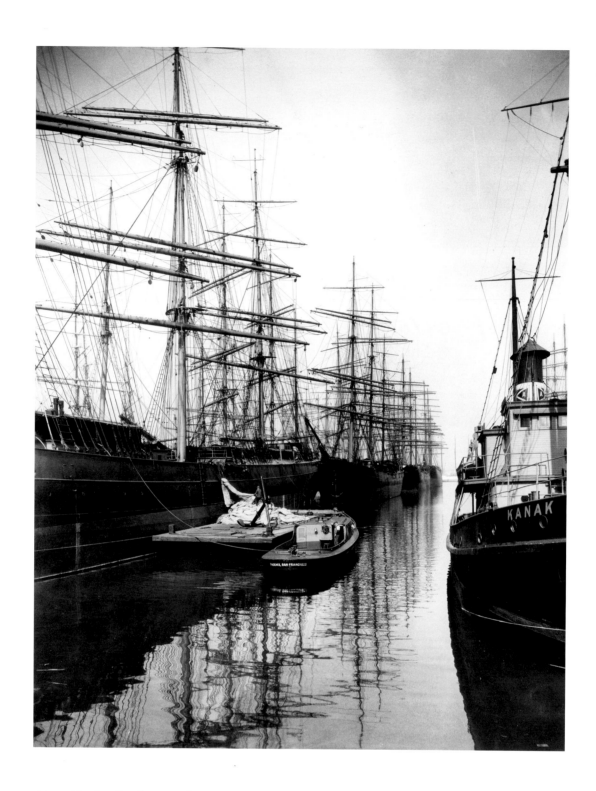

88. Alaska Packers at San Francisco, 1907–28

Unidentified photographer
Gelatin-silver print
Edward S. Clark Collection, 1952

When this photograph was taken, the ships of the Alaska Packers Association were the last American square-riggers in service. The photographer utilized the overlapping pattern of the masts and spars to create a serene image that reflected on the waning days of sail.

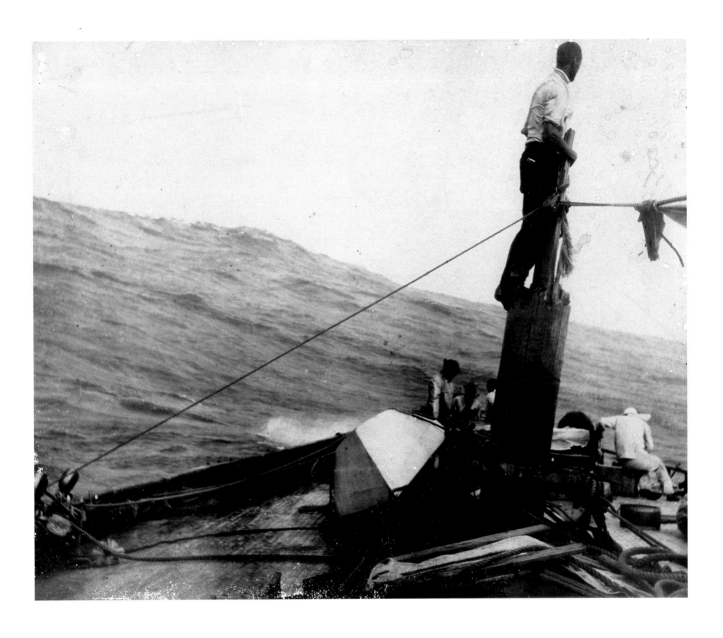

89. *Dismasted Schooner in High Seas, circa 1930*

Unidentified photographer
Gelatin developing-out paper
Gift of Lawrence White, 1977

Nothing is known of the incident, the schooner, the mariners, or their ultimate fate beyond what is depicted in this photograph. The crew has obviously survived some violent act of nature but, unable to make sail, remain at the mercy of the high seas. Whatever the final outcome of this particular encounter with the elements, the existence of this image stands as a testament to a seagoing photographer's motivation to record the most dire of circumstances.

90. "A Truly Early American Room," the Smoking Lounge of S.S. Washington, *circa 1933*

Attributed to Byron and Company
Gelatin-silver print
Gift of the United States Lines, 1951

When *Washington* departed from New York for Hamburg on her maiden voyage in May of 1933, she was the largest ship ever built in America. The United States Lines released this promotional photograph prior to her initial sailing, along with a press release that highlighted the ship's elegantly appointed interior: "Nowhere is the creative genius of the decorators of the *Washington* more apparent than in this ruggedly beautiful room that takes its origin in the primitive life and art of the American Indian. The spirit, the color and the crude motifs of the red man, here glorified into beautiful modern design, appear in the fabrics, the ornamentation of the room and the carvings."

91. *Unidentified Couple (Bowditch Family), circa 1935*

Unidentified photographer
Gelatin printing-out paper with hand-applied coloring
Gift of Beverly and Joe Sturgeon, 1992

92. *S.S.* Dixie *in the Center of a Hurricane off the Florida Coast,*
 2 September 1935

G. J. Tregar
Gelatin-silver paper
Gift of Mrs. Clarkson A. Cranmer, 1955

"Taken from the top deck. Height of wave, 65 feet. A wall of water."

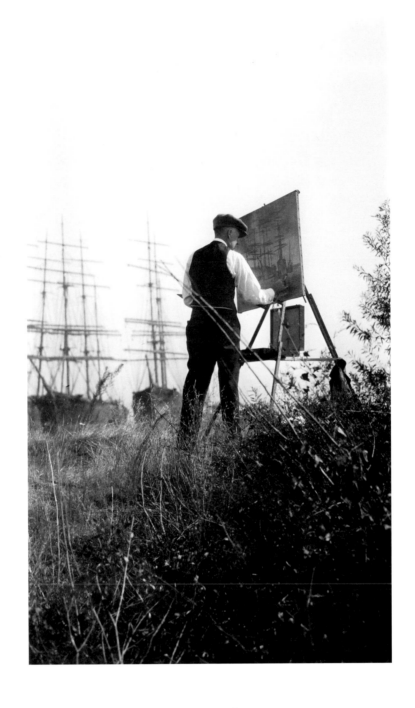

93.　*A Marine Painter at Work, 1940–45*

Unidentified photographer
Acetate film negative

Turning the lens toward a painter at work, the photographer
captures the inspiration for the creation of all marine art. After
a thirty-year career as a deepwater mariner, Charles Robert
Patterson (1878–1958) left the sea to take up painting, specializing in the subject he knew so well.

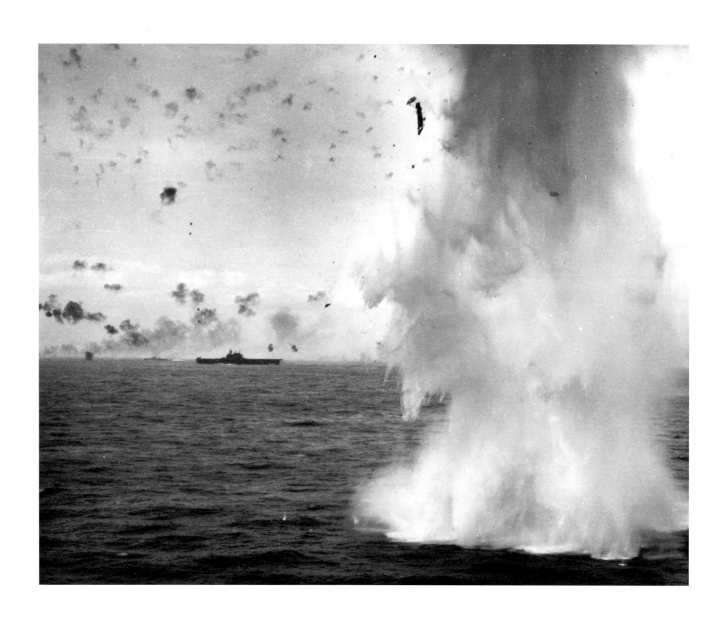

94. *Kamikaze Crashes alongside the Carrier* Essex, *off Okinawa, 1945*

U.S. Navy photographer
Gelatin-silver print
Gift of Paul J. Madden and Robert F. Hayes, 1987

A Japanese plane crashes perilously close to the carrier *Essex* during an offensive near the island of Okinawa. Two months earlier, a kamikaze had hit the *Essex*'s flight deck where planes were fueled for takeoff, killing fifteen and wounding forty-four men.

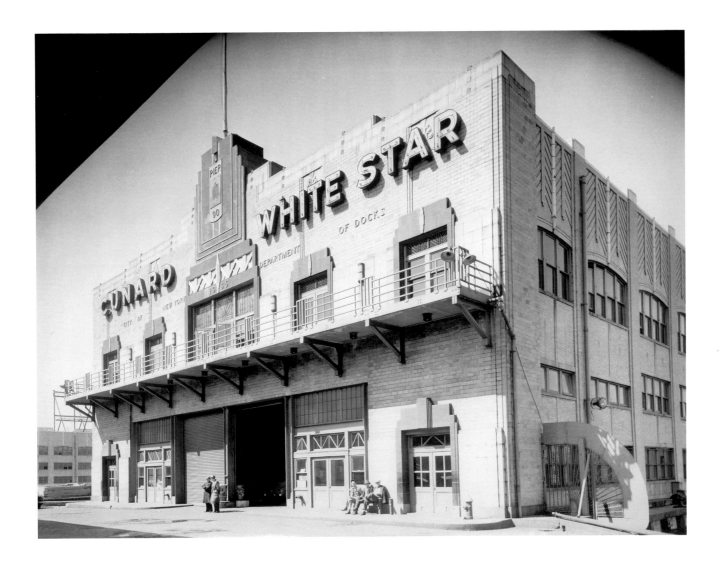

95. *Cunard White Star Pier 90, North River, New York, 1940–50*

Unidentified photographer
Gelatin-silver print
Gift of Mrs. R. G. M. Hunt, 1983

The ornamented facade of the Cunard White Star Line's Hudson River pier facility stands behind the elevated West Side Highway. The photographer's wide-angle lens accentuates the angular patterns distinctive of art deco architecture.

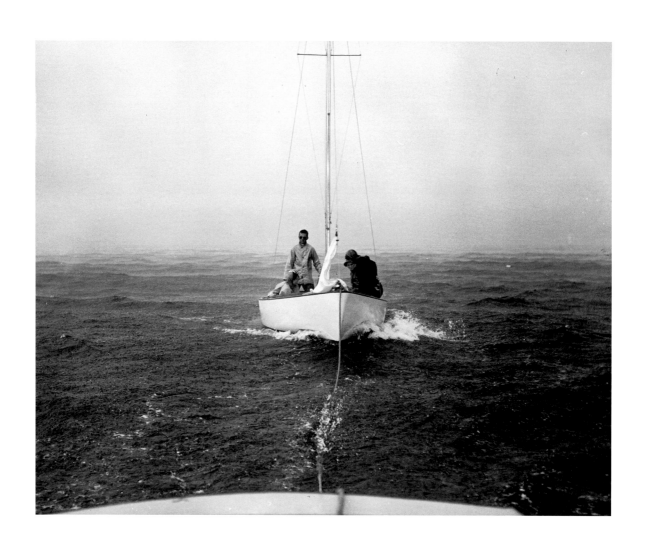

96. *Sailboat Towed during a Downpour, 1950–55*

Ronald E. Stroud
Gelatin-silver print
Ronald Stroud Collection

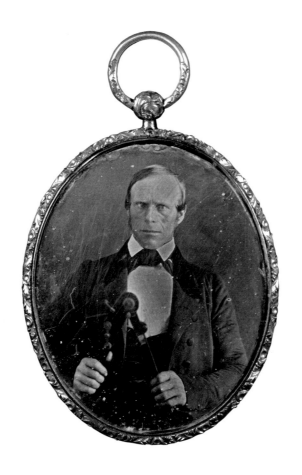

97. *Sailor with a Sextant, circa 1860*

Unidentified photographer
Daguerreotype
Purchased in memory of Austin K. Smithwick by fellow
museum volunteers, 1982

Sailors frequently sat for their painted portraits accompa-
nied by objects symbolizing their profession. Miniature
portraits were often mounted into pendants as keepsakes
for loved ones at home. This daguerreotype portrait is
mounted into a gold locket containing hair from the sitter.

ENDNOTES

1. Charles Edey Fay, Mary Celeste: *The Odyssey of an Abandoned Ship* (Salem, Mass.: Peabody Museum of Salem, 1942). Although many volumes have been written about this mystery, this book provides a concise summary of the incident.

2. George W. DeLong, *The Voyage of the* Jeannette (Boston: Houghton Mifflin, 1884).

3. W. Parry, "Some Experience in Photographing Steamships" in the *American Annual of Photography and Photographic Times Almanac* (New York: Scovill and Adams, 1890): 105.

4. John Rousmaniere, "Looking for the One Shot: An Interview with Stanley Rosenfeld," *Woodenboat* 90 (1980): 51.

5. Parry, "Some Experience in Photographing Steamships," 105–6.

6. William Henry Bunting, *Steamers, Schooners, Cutters, and Sloops* (Boston: Society for the Preservation of New England Antiquities, 1974), 8.

7. Parry, "Some Experience in Photographing Steamships," 106.

8. *The Invention of Photography and Its Impact on Learning* (Cambridge, Mass.: Harvard University Library, 1989), 8; an exhibition entitled *The Museum and the Photograph: Collecting Photography at the Victoria and Albert Museum* (1998); and Nils Ramstedt, "An Album of Seascapes by Gustave Le Gray," *History of Photography* 4 (1980): 121–37.

The importance of Le Gray's photographs have, of course, been discussed in a great many other sources.

9. Grace Seiberling and Carolyn Bloore, *Amateurs, Photography, and the Mid-Victorian Imagination* (Chicago: University of Chicago Press, 1986).

10. A. J. Peluso Jr., "New York Marine Photographers," *American Neptune* 58 (1998): 5–23.

11. Chris Steele and Ronald Polito, *A Directory of Massachusetts Photographers, 1839–1900* (Camden, Maine: Picton Press, 1993), 169.

12. Thomas J. Schlereth, "Mirrors of the Past: Historical Photography and American History" in *Artifacts and the American Past* (Nashville, Tenn.: American Association for State and Local History, 1980), 11–47.

13. *A Shifting Focus: Photography in India, 1850–1900* (London: British Council, 1995), 66. The exhibition was organized by Brett Rogers and Sean Williams.

14. John Thomson, *Through China with a Camera* (Westminster: A. Constable and Company, 1898), 83–84.

15. John Falconer, *A Vision of the Past: A History of Early Photography in Singapore and Malaya, the Photographs of G. R. Lambert and Co., 1880–1910.*

16. Robert Nunez Lyne, *Zanzibar in Contemporary Times: A Short History of the Southern East in the Nineteenth Century* (London: Hurst and Blackett, 1905), 100.

INDEX AND SELECTED BIOGRAPHIES OF
MARITIME PHOTOGRAPHERS

Felice Antonio Beato (1825–ca. 1904)
Group of Japanese Junk Boats in the Canal, Japan, 1867–68
[**image 19**]

Venetian-born Felice Beato arrived in China in 1860 during the last part of the Second Opium War. He had photographed previous military campaigns, both the Crimean War and the aftermath of the Indian mutiny as the assistant to James Robertson. In China, he followed the Anglo-French North China Expeditionary Force during the occupation of Peking and the sack of the Imperial Summer Palace, photographing Chinese architecture, people, and panoramic harbor views. Later, Beato traveled to the Near East, and in 1864, to Japan. He followed the American expeditionary force into Korea in 1871, photographing the aftermath of that engagement. He worked from Yokohama until 1877 when he sold his business. It is variously reported that, during the 1880s, either he or a brother named Antonio photographed in the Nile valley, and later set up a mail-order business in Burma.

Bedford Lemere and Company
First-Class Swimming Bath, S.S. Empress of Australia, *circa 1922* [**image 85**]

James Wallace Black (1825–96)
Glory of the Seas *on the Ways, October 1869* [**image 20**]
U.S. Revenue Steamer Levi Woodbury, *circa 1865* [**image 15**]

Born in New Hampshire, Black began work in Boston and soon became a partner of the famous astrophotographer John Whipple. In 1860, Black struck out on his own and quickly achieved fame with a series of aerial views taken from a balloon. His studio became the largest in Boston, employing over sixty men and women in all facets of his operation. Although most attention has been paid to his aerial and New Hampshire nature photography, Black photographed many urban industrial and harbor views. In 1869, John L. Dunmore, an assistant representing Black's studio, sailed to the Arctic with the artist William Bradford. The voyage yielded several hundred large-plate negatives of icebergs and scenes of Labrador, a selection of which Bradford later published, crediting Black.

Mathew B. Brady (1822–96)
Commander W. A. Parker and Officers on the Deck of U.S.S. Tuscarora, *1863–65* [**image 12**]
The Ships Antarctic *and* Three Bells *Rescuing Passengers on 24 December 1853 from the Steamship* San Francisco, *1854–60* [**image 2**]

Mathew Brady is considered one of the most important early American photographers. Introduced to photography in 1840 by Samuel F. B. Morse, Brady opened his first gallery four years later in New York, and thereafter a gallery in Washington, D.C. Well established by the outbreak of the Civil War, he and the other photographers in his firm recorded many images of the battlefields and war participants. While it is unknown how many photographs Brady himself actually made, his artistic vision and personal finances were responsible for these accomplishments. Among the photographers working for the company were Alexander Gardner, James Gibson, George Barnard, and Timothy O'Sullivan. On occasion, Brady had between twenty and thirty bases of operation covering the war. Through Brady's studios, the grim realities of war were brought home to civilians.

James Burton (1871–1909)
On Board the Reliance, *1903* [**image 68**]

Born in London, Burton came to the United States in 1894 as an illustrator. After covering the Spanish-American War for *Harper's Magazine,* he advertised himself as a "camera artist" and a dealer in photographic materials. In 1900, his establishment was at 9 West 42d Street in New York City. Mystic Seaport Museum holds over one thousand glass-plate negatives created by Burton, who was also an early employer of yacht photographer Morris Rosenfeld.

Joseph Byron (1846–1923)
"A Truly Early American Room," the Smoking Lounge of S.S. Washington, *circa 1933* [attributed to Byron and Company] [**image 90**]

Byron was born in England into a family of photographers based in Nottingham. He immigrated to America in 1888

and set up his business in New York. He specialized in architectural views, domestic and commercial interiors, theatrical views, and society portraits. Byron and his studio workers are characterized by their heavy use of flash powder to manipulate light for their images. After Joseph died, his son Percy (1879–1959) continued the company until 1942.

Jerome J. Collins (d. 1881)
In the Ice, 1879 [attributed] [image 28]

Born in Ireland and trained in engineering, Collins was working as a meteorologist for the *New York Herald* when he was assigned to the *Jeannette* arctic exploratory expedition in 1879. He carried with him camera equipment and a portable darkroom, but no photographic images of the expedition appeared in any official or unofficial account of the voyage.

Comianos et Sarolidis
The Arrival of the Prince of Wales in Port Said, October 1875 [image 29]

Baldwin Coolidge (1845–1928)
Wharf at Edgartown, Martha's Vineyard, Massachusetts, circa 1880 [image 33]
Reflecting upon a Wreck at 'Sconset, Nantucket, Massachusetts, circa 1885 [image 37]

Coolidge began life as a photographer's assistant and set up his own studio in Boston in the 1890s. He found success selling photographs of art works exhibited in the Museum of Fine Arts and photographic sets of Boston's historical landmarks.

Frank Cousins (1851–1925)
Yacht Race off Marblehead, 16 July 1891 [image 43]

Cousins was a dry goods merchant and a specialist in colonial architecture, which he wrote about and photographed extensively. Later in life, he became a professional architectural photographer. The museum holds several thousand prints and negatives of New York, Philadelphia, Washington, D.C., and Salem views by him.

Mrs. James A. M. Earle (active between 1890 and 1906)
Scenes on Board the Whaler Charles W. Morgan [image 49]

William Prior Floyd (active between 1865 and 1874)
Photographers' Studios, Queen's Road, Hong Kong, 1865–74 [image 24]

W. P. Floyd was a commercial photographer working in Shanghai, Macao, and Hong Kong. He maintained the Victoria Photographic Gallery in Hong Kong until 1872.

Augustine H. Folsom (active between 1868 and 1926)
Boston and Bangor Steamboat Cambridge, *circa 1885* [figure 3]

Folsom was a commercial photographer who specialized in images of machinery and architecture. He operated from 48 Alleghany Street in Roxbury, Massachusetts, for the entirety of his lengthy career.

James Freeman (1814–90) and William Freeman (1809–95)
Pyrmont Patent Slip, Sydney, John Cuthbert Proprietor, with the Ships Castilian *and* King Philip *Hauled Up for Repairs, circa 1867* [image 17]

William Freeman arrived from England in 1853, and his brother joined him the following year. William Freeman had practiced daguerreotypy in Somersetshire in the 1840s. At the outset of their operations in Sydney in the mid-1850s, their clientele preferred daguerreotypes over newer forms of photography, but in 1858 and again in 1859, their paper-print panoramic views of the town and harbor of Sydney were described in the newspaper.

Gibson and Sons (active between 1880 and 1900)
Wreck of the S.S. Malta *at Land's End, 1889* [figure 4]
Wreck of the Ship Granite State *of Portsmouth, New Hampshire, at Land's End, 1895* [image 54]

Wilhelm Hester (1872–1947)
Lumber Mill, Port Blakely, Washington, circa 1900 [image 74]

Wilhelm Hester took up photography in 1893, after immigrating to Seattle from northern Germany. To stir up business, he drove, sailed, or steamed his way between Tacoma, Port Blakely, and Seattle with lists of newly arrived ships. Boarding as many ships as possible, he set up appointments to shoot images of the captain and crew, deck scenes, and broadsides. Once the plates were exposed, he took orders for prints. The plates were developed at several firms around Puget Sound and returned to Hester for his meticulous printing instructions. By 1898, however, Hester and his brother Ernst got gold fever and raced off to find their fortune in Alaska. Back in Puget Sound by 1899, Wilhelm had again assumed his work as a commerical photographer. He

gave up photographing maritime subjects in 1906 in pursuit of a more lucrative career.

H. Ibbetson (active 1924)
Bark Garthsnaid *from S.S.* Ionic *off Cape Horn, 1924* [**figure 7**]

Andrew Jackson (active between 1859 and 1866)
Erie Dock, Brooklyn, New York, 1864–66 [**image 14**]

A resident of Brooklyn, Jackson operated studios on New Bowery and Grand Street in Manhattan. He was still advertising daguerreotypes in 1864, after most photographers had adopted other photographic processes.

Willard Bramwell Jackson (1871–1940)
Dorothy Q *and* Little Rhody II, *13 July 1907* [**image 72**]

Jackson spent most of his career as the Boston manager for the English steel company of William Jessop and Sons. Spanning the years between 1898 and 1936, Jackson was often aboard his powerboat *Alison* off Marblehead recording an important era in American yachting. He was a meticulous craftsman with a visionary artistic skill, yet photography was more of a hobby than a profession to him. He built much of his own photographic equipment and displayed a remarkable talent for composing his subjects. The museum houses over thirty-three hundred Willard Jackson negatives of which over twenty-five hundred are large-format glass plates. These negatives were rescued from a fire that destroyed the Jackson home after his death.

Johnston and Hoffman
Eden Gardens, Calcutta, India, 1870–80 [**image 26**]

With a studio at 22 Chowringhee Road, Calcutta, and offices in Darjeeling and Simla, these partners produced a broad range of Indian views.

G. R. Lambert (active in Singapore, 1867–86)
Tanjong Pagar Dock, Singapore, circa 1880 [**image 31**]

G. R. Lambert arrived in Singapore from Dresden in 1867 and opened a photographic studio on High Street. Though based in Singapore, he took numerous sojourns back to Europe and around Southeast Asia, including one in the late 1880s to Siam. The firm opened several satellite operations in Sumatra, Kuala Lumpur, and other locations where international commerce brought traveling Westerners. Upon his departure from Singapore around 1886, he left his

business under the management of his partner Alexander Koch. The company continued under Lambert's name until 1918.

Edwin Hale Lincoln (1848–1938)
Cockpit of Dauntless, *circa 1880* [**image 30**]

Edwin Lincoln served as a drummer boy in the Civil War and took up photography in 1877, achieving success with his dry-plate views of famous Boston yachts and other wooden ships. He claimed to have been the first to photograph the yacht *America*. Influenced by his friend Oliver Wendell Holmes, he investigated nature photography and eventually moved to the Berkshires to pursue it on a full-time basis. He produced a three-volume work called *Wild Flowers of New England*. Lincoln typically used a camera without a shutter and covered with a blanket to be lifted and dropped for the exposure, and he printed his work exclusively on platinum paper.

David Mason Little (1860–1923)
Puritan *at the Finish of the Eastern Yacht Club Race, 29 June 1886* [**image 40**]

David M. Little studied as a naval architect at the Massachusetts Institute of Technology and in the shipyards of the Clyde in Scotland. He was a commander in the naval reserve and was in charge of operating nine naval repair yards. He also designed and built sail and steam yachts. Later, he served as the mayor of Salem. Little traveled to England upon the advent of dry-plate photography and was among the first to apply the technique to yachts in motion. His book *Instantaneous Marine Studies Taken by David Mason Little* published in 1883 was ground-breaking in its clear and artistic depiction of fast-moving yachts. Contemporary reviews credited Little with being the first American to utilize dry-plate photography for marine subjects.

Thomas Addis Emmet Luke (1861–1932)
Ship A. J. Fuller *at South Street, New York, circa 1895* [**frontispiece**]

A talented amateur, Luke was a repairman for the Putnam Machine Company in Fitchburg, Massachusetts. He photographed principally in Boston, New York, and Seattle. He subscribed to the *New York Herald* and when the shipping news announced the arrival of an interesting ship, he traveled there to photograph it. The Peabody Essex Museum holds a considerable number of glass-plate negatives by Luke.

Mitoma
Loading Coastal Colliers, Japan, 1895 [image 46]

Enrique Muller (active 1906)
U.S.S. Connecticut *on Her Trial Run, 1906* [image 71]

Muller worked for the Detroit Publishing Company (see entry for Henry Peabody).

Lafayette V. Newell (1833–1914)
U.S.S. Isla de Cuba, *1904–7* [image 70]

Lafayette Newell began work as a calligrapher in Concord, New Hampshire, in 1854 where he also took up photography. He was active during the Civil War making portraits of Confederate and Union soldiers. He returned to Portsmouth and worked both as a photographer and as a partner in a grocery store with his father-in-law. His son John joined him and photographed many prominent residents of Portsmouth, in addition to ships and shipyard scenes.

Henry Greenwood Peabody (1855–1951)
Deck of the Sandy Hook Lightship, circa 1894 [image 52]
Seguin Light, Maine, 1886–1900 [image 44]

Henry Peabody specialized in yacht, landscape, and architectural photography while working in Boston between 1886 and 1900. He was hired by William Henry Jackson and the Detroit Publishing Company as a roving photographer in California. Afterwards, he developed a speciality in nature photography and leased the concession to photograph tourists at the Grand Canyon. He also produced striking images of the canyon itself as well as the published volume entitled *Representative American Yachts* (Boston, 1891).

Pearson and Paterson (active 1864)
Aftermath of the Bengal Cyclone, 5 October 1864 [image 13]

Frederick S. Rankins (active between 1916 and 1946)
Theophilus Brackett, circa 1916 [image 79]

Rankins was a commercial photographer at 24 Franklin Street in Lynn, Massachusetts, and advertised panoramic photographs of outings and conventions. His "Old Swampscott Fishermen Series" demonstrated his skill as a maritime photographer.

Selwyn C. Reed (active between 1869 and 1898)
Lifesavers to the Rescue of the Schooner Jennie Carter *in 1894, Salisbury Beach, Massachusetts* [image 47]

Reed worked as a professional photographer with his father, Daniel, and brother Edgar. He was also chief engineer for the Newburyport, Massachusetts, fire department.

Charles Spitz (1857–94)
Manihinihi (Chickie), Papeete, Tahiti, 1899–1900 [attributed] [image 61]

Spitz arrived in Tahiti from his native Alsace by 1880. He set up a studio in Papeete exhibiting Tahitian photographs for sale to travelers, and also back in Paris, where he received an honorable mention at the Exposition universelle in 1888. The business was continued into the twentieth century by George Spitz, presumably his son, who advertised the sale of curios, postcards, photographs, and souvenirs.

Nathaniel Livermore Stebbins (1847–1922)
Ship Hotspur *of New Bedford, 1885* [image 38]

In 1889, Stebbins was the only photographer represented among the artists at the International Maritime Exhibition in Boston, denoting the high regard in which his work was held by his contemporaries. He became interested in photography after setting up a darkroom in his bathroom in 1882. He soon left a career in the furniture business to take up photography full time. According to his own records, he made over twenty-five thousand photographs, fifteen thousand of which were maritime subjects. He published numerous volumes of marine photography, including *American and English Yachts* (New York, 1887), *Yachtsman's Souvenir* (Gardner, Mass., 1888), and *The Illustrated Coast Pilot* (Boston, 1891).

Ronald E. Stroud (active between 1950 and 1955)
Sailboat Towed during a Downpour, 1950–55 [image 96]

Ronald Stroud began summering in Marblehead and by 1950 had a year-round residence on Atlantic Avenue. During the following five years, he produced twenty-one albums of photographs, mostly of local fleets and one-design races. His original proof prints and negatives are in the museum collections.

Frank Meadow Sutcliffe (1853–1941)
*Women and Children of the Fishing Port of Whitby, England,
circa 1890* [image 42]

Sutcliffe took pictures of fishermen and other members of
the community of Whitby for more than thirty years. The
people he depicted, though usually highly composed in
posture and positioning, are invariably presented within
their natural milieus, wearing their own working clothes.
Men are depicted returning from the fishing grounds, chil-
dren playing by the shore, and women performing shore-
side tasks related to fishing. Sutcliffe particularly liked the
use of stark light and shadows on the figures, often en-
hanced by thick fog.

John Thomson (1837–1921)
Chinese Junk, 1868–72 [image 21]
Wanchi Steam Bakery, Hong Kong, circa 1875 [attributed]
[image 25]

Thomson spent a decade creating a photographic record of
his travels through China, Malacca, Cambodia, Siam, and
Formosa, taking all the equipment for wet-plate photogra-
phy along with him. He published several volumes of his
work before returning to England in 1872, including
Antiquities of Cambodia (1867) and *Views of the North River*
(1870). On his return, he published the four-volume set
Illustrations of China and Its People (1874). He lived in
London, and photographed on commission. Thomson was
also appointed photographer to Queen Victoria, and served
as an advisor to the Royal Geographic Society.

G. J. Tregar
*S.S. Dixie in the Center of a Hurricane off the Florida Coast,
2 September 1935* [image 92]

Paul Verkin Sr. (1862–1936)
*Fo'c'sle Quarters on Board the Tug Charles Clarke, Galveston,
Texas, 1920–30* [image 87]

The German-born Verkin immigrated to the United States
in 1876, where he learned photography. He later moved to
Texas, working as a photographer in Mexia and Denison
before settling in Galveston in 1898. He opened an office in
1905 billing himself as a view photographer. His sons Paul
Roland, Louis, and Melvin assisted him with the business,
Paul being the only one to continue as a photographer. The
Verkins specialized in documenting the activities along the
Galveston waterfront, often on commission from the busi-
nesses along the harbor. The Peabody Essex Museum holds
over three thousand negatives taken by the Verkins.

George H. Wilbur (active between 1897 and 1900)
Artifact from the Steamer Portland, circa 1900 [image 64]

Capturing Poseidon: Photographic Encounters with the Sea

was designed by Dean Bornstein,
printed by The Stinehour Press in Lunenburg, Vermont,
and bound by Acme Bookbinding in Charlestown, Massachusetts.
All of the images in the gallery section were photographed
using a Phase One *Power Phase* digital back
by Peter Bittner and Shane Young of Spring Street Digital, Incorporated
and converted for duotone printing by Fletcher Manley.